people

of the

flower

market

DEDICATION

It was in October of 1986 that I first visited New Covent Garden Flower Market, a wide-eyed Warwickshire lad lucky to be in the company of the late Robert Day, an incredible florist and a special friend. The memory of that chilly morning remains deep in my heart and soul for many reasons: the assault on my senses of the abundance of blooms, the bustle, and the people. It was on that morning I first met **Dennis Edwards**, who faithfully served Robert, and who, as I write this towards the end of 2019, continues unfailingly to supply me with flowers. It is to Dennis, and to the men and women who work in New Covent Garden Flower Market, that I would like to dedicate this book – a small acknowledgment of the enormous contribution that they have made, and continue to make, to my life and to the lives of those to whom we add our floral fabulousness. Thank you.

Simon Lycett, December 2019

people

of the

flower

market

SIMON LYCETT

Photography by Michelle Garrett

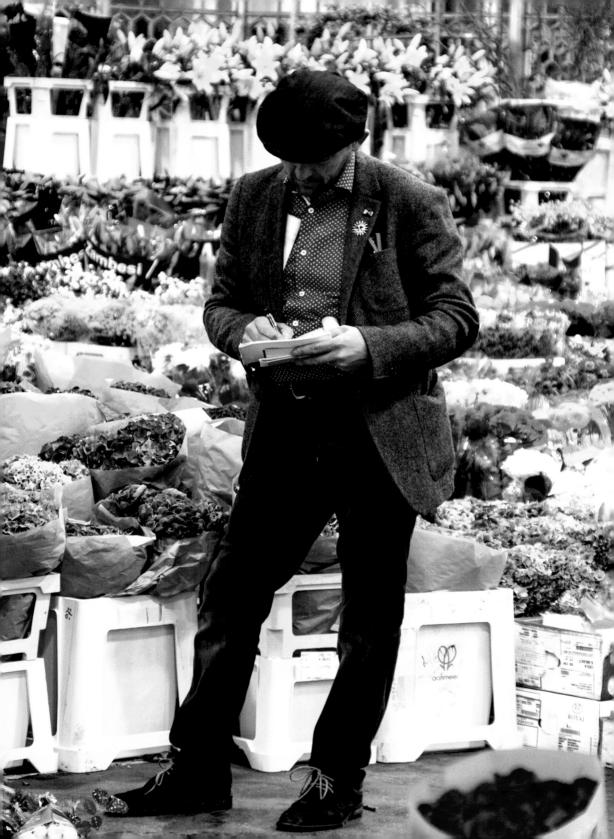

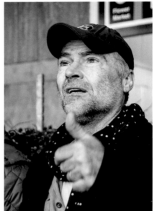

The People of the Flower Market
First published by
Simon J Lycett Ltd in 2020
Arches 270-272, Bethwin Road
London SE5 0YW
www.simonlycett.co.uk

Designed, edited and produced
by Berry & Co (Publishing) Ltd
www.berrypublishing.co.uk

Designer Steven Wooster

British Library Catologuing in
Publication Data
A catalogue record of this book
is available from the British
Library

ISBN 978-1-91609-12-2-1

Printed in China

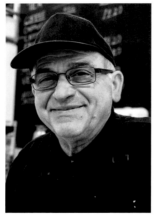
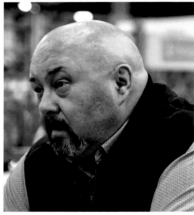

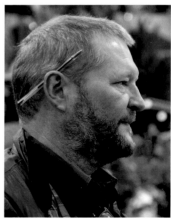

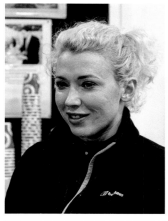

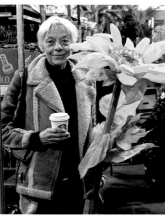
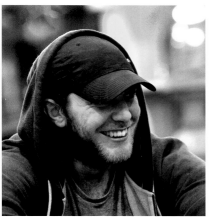
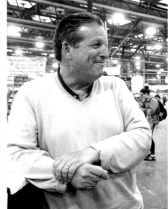
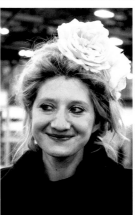
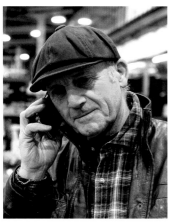
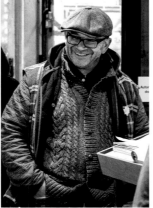
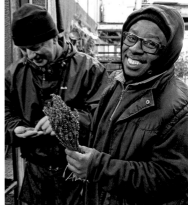

contents

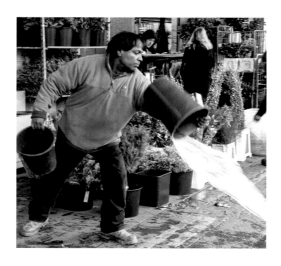

foreword

More than 30 years ago, what struck me, as a naïve 20-year-old entering New Covent Garden Flower Market for the first time, was the sheer abundance of the flowers, in colours and varieties gathered from every corner of the world. Within a few weeks of experiencing this beauty-filled yet intimidating environment, it revealed another fascinating quality — it is the most magical of melting pots where a myriad different people gather with just one common thread: their appreciation of flowers. Just as blooms and bunches from all parts of the world are assembled beneath one roof, so too are all of man- and womankind: from Cockney wholesalers and porters to the Essex and Kent family market gardeners; from the grandest of Home Counties ladies, accompanied by their drivers, to the toughest, shrewdest stall holders from second-generation immigrant stock.

Echoing the magical and mad mixture of foliage, flowers, plants and plant materials that jostle on every stand, those who make the journey to market in South London before dawn each day are as diverse a group of flower folk as you would ever wish to meet. Many of them have since become my friends — engaging and eccentric, they together make up the inimitable and unique **People of the Flower Market**.

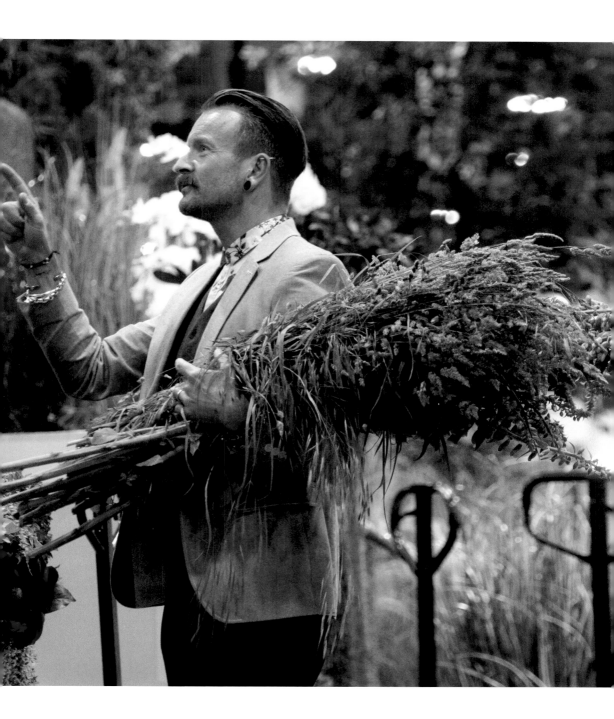

introduction

Work at New Covent Garden Flower Market is physically demanding, from its anti-social hours in a perennially cold and damp space to the heavy lifting of bloom-laden boxes, and endless shifting of buckets of water. It takes a certain kind of character to cope with such trials — to manage the stock, and keep the pickiest of customers happy enough to return for more.

In 2016 Covent Garden Market Authority began the redevelopment of the combined fruit, vegetable and flower markets that had been operating out of obsolete and impractical premises built in the 1960s and no longer fit for purpose. Knowing that the Flower Market was to be relocated a few hundred yards along Nine Elms Lane, and that the existing buildings were all to be demolished to make way for a newer, more compact, combined Market, and a series of residential properties, I felt it important to document what was the end of an era.

After 30 years of buying from the Flower Market every bloom, plant, stick and stem of foliage that we at Lycett Towers use daily to create our floral fabulousness, I've grown to know many of the suppliers and my fellow buyers too. From the initial greeting — a quick smile or a quiet, nodded 'Good morning' — to gradually knowing their names, firm and loyal friendships have developed. The trust that I place in my suppliers is paramount, for it is only with their diligence and their ability to satisfy my ever-more demanding demands that we achieve those amazing feats of floral creation for which we have developed a world-wide reputation.

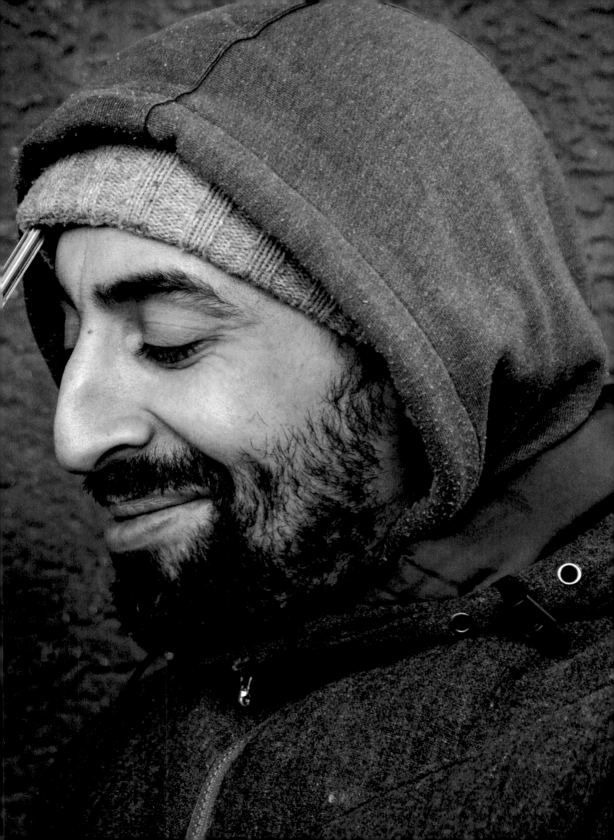

faces of the market

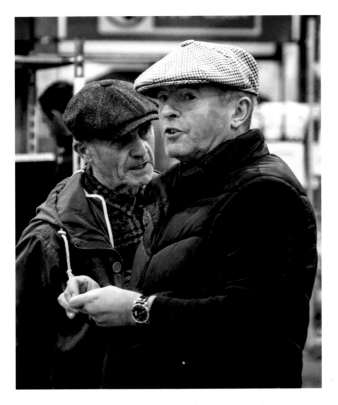

Alan Martin, one of three generations of the Martin family, who have worked and still work at the Market, sharing a few comments with Trevor Clackett, another Flower Market stalwart.

The chat that occurs in the Market is one of its major characteristics. From the light-hearted joshing between 'rival' companies to the unending banter and badinage, it's always hugely entertaining, often near-the-knuckle, but never mean. I've been lucky enough to have become a fairly frequent face of British floristry on TV in the UK and beyond, as well as appearing on slots on BBC Radio London. These events always garner a fair few comments, many hilarious, and all kindly meant. It's certainly a great leveller – I won't get big headed, that's for sure!

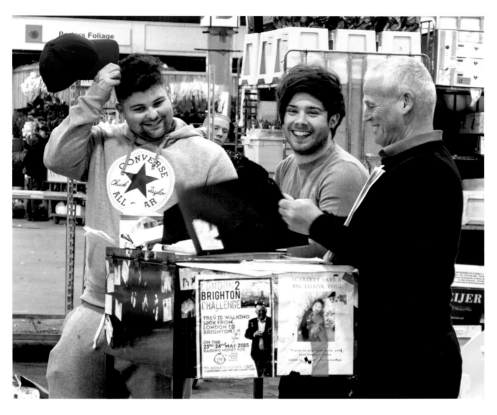

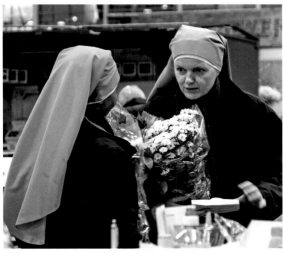

The joy of visiting the Market is that the people add a frisson of fun to early-morning buying trips. There is rarely a dull moment among the fabulous flowery folk, either overhearing the gossip and the regular bawdy banter between the 'boys' or catching a brace of nuns bargaining over blooms for the Lady Chapel.

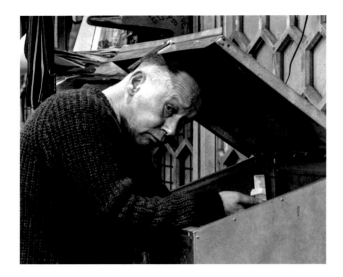

Humour is never far away on the market floor. Elvis, left, is clearly enjoing a joke as Jim Donovan (right) looks on. Is Elvis his real name? Who knows! I've only ever known him as Elvis!

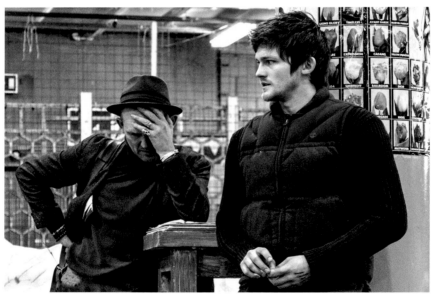

Eddie and Sonny Martin, a father and son team, are stalwarts of the Market. Sonny, once a child star, playing Gavroche in Les Miserables in London's West End — now has the Market as his stage, selling flowers and sometimes treating us to an early-morning-medley of whatever songs he fancies. Judging by his expression, father Eddie may have heard them once too often!

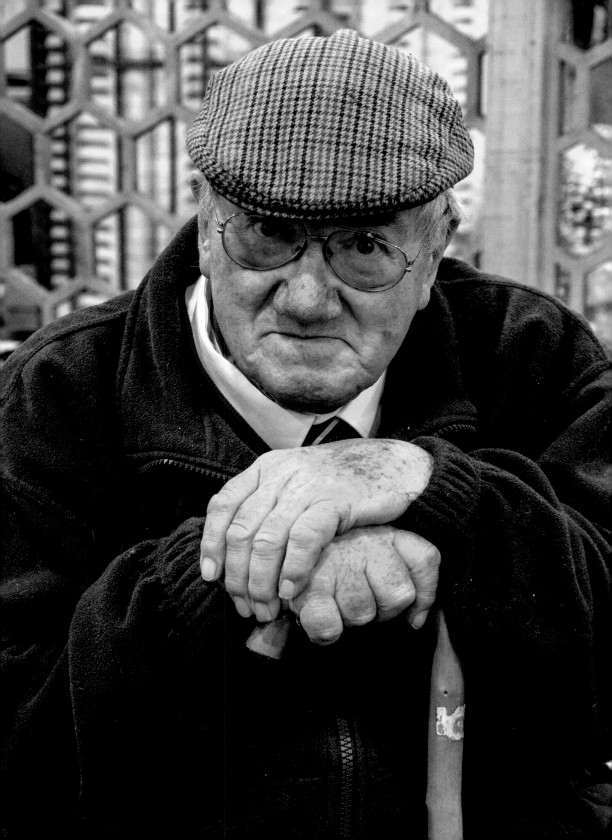

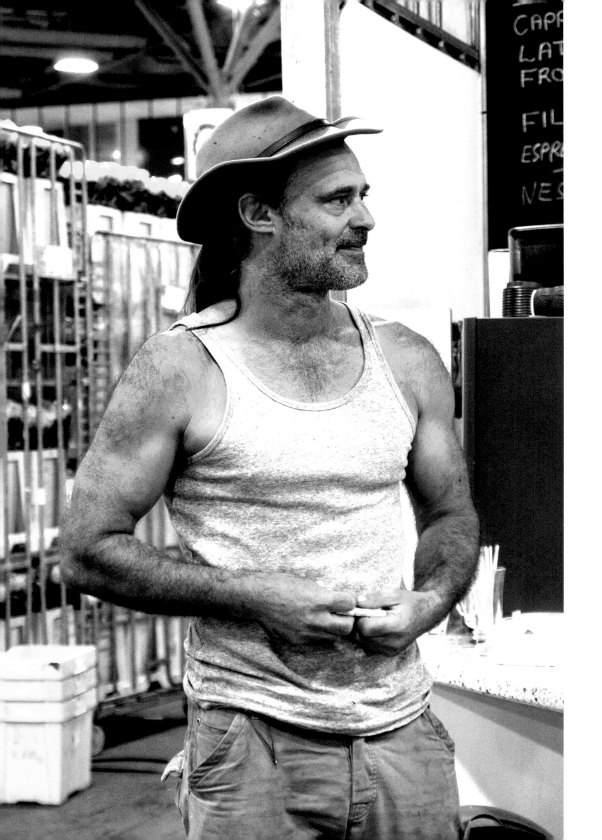

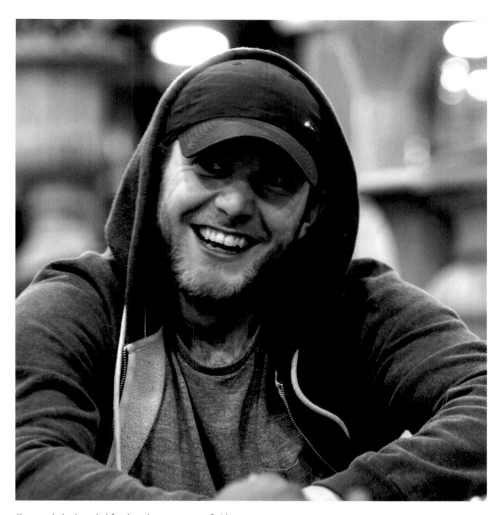

Young Ash (or Ashley), above, one of the newer generation of 'gents' working on one of the sundries wholesale stands. One of the cheekiest chaps, always ready with an incorrect comment and a wayward glance!

Something has amused this urban cowboy, left, while taking a break for a cuppa and bacon sandwich before heading off to his van, laden with plants, to glorify a client's garden.

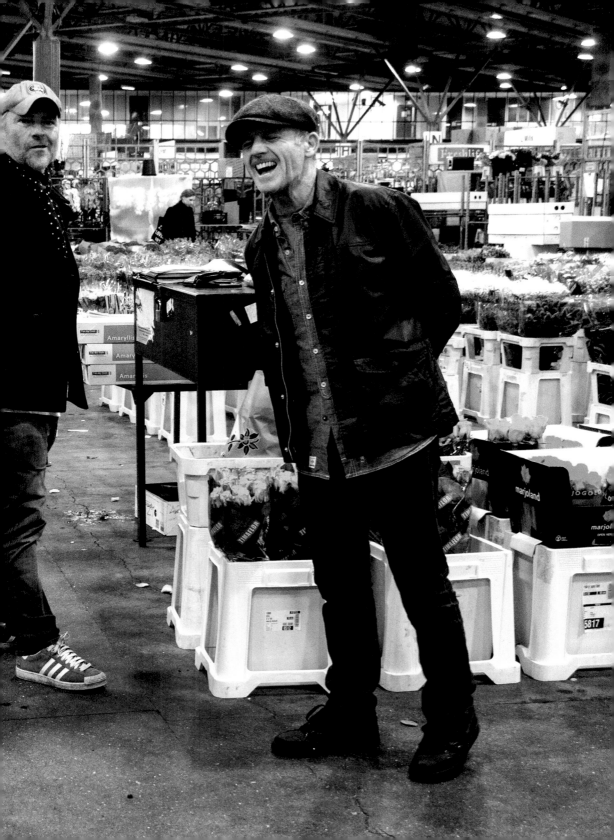

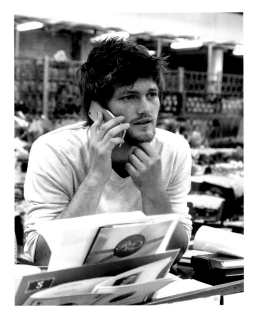

Sonny in serious mode while Grant Wilde ('little Ron') smiles for the camera...

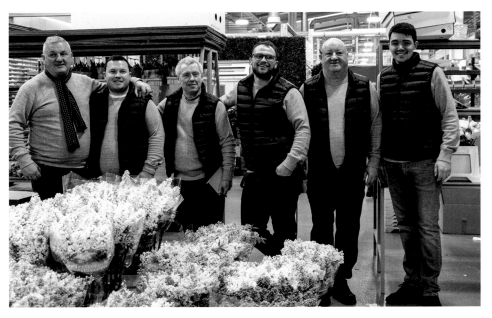

... as do the dapper gents of Bloomfields, lined up for the shot!

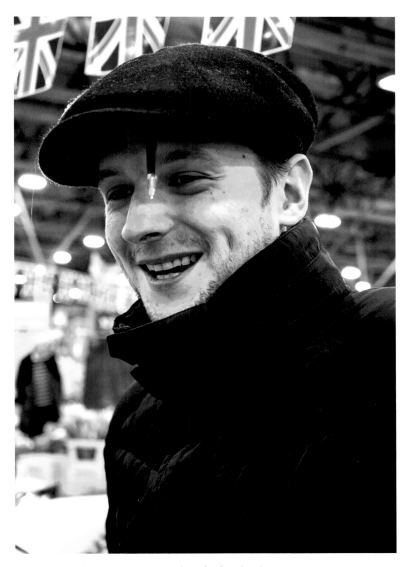

The cap may be better known than Saul, who is never seen
without it. It usually holds his pen! Saul is one of the
new generation of market wholesalers. A champion of the
British growers, his enthusiasm for boxes of blooms and his
understanding of the needs of us florists makes him a joy
to deal with on a daily basis.

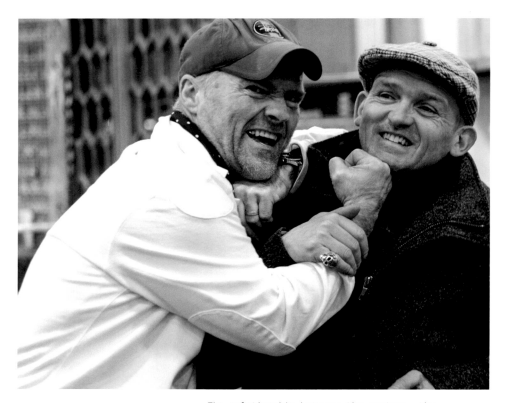

The relationship between the porters, the wholesalers and the customers at the Market is symbiotic — each relies on the other to get the purchases out to vans and vehicles before the morning rush begins. The eponymous Maurice, right, one of the most well-known porters in the Market, hams it up for the camera (above) with wholesaler Eddie, seen with his son on page 14.

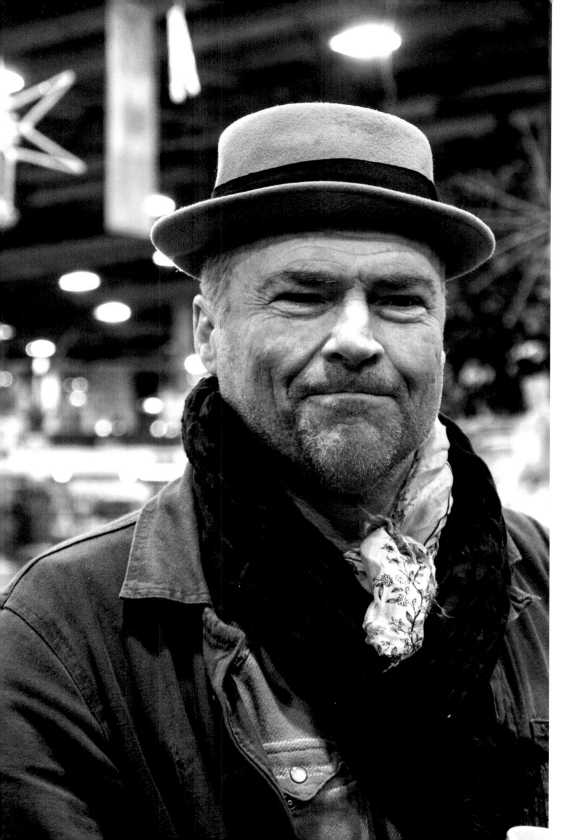

doing the business

Not just the Market but also its contents change with time. Orchid flowers, left, were a rarity when I first started working in London in the late 1980s. Now they are ubiqitous, some even grown not many miles from London.

Eddie again, right, doing business on his phone. In 1987 when I first visited the Market, faxes were the thing and mobile phones were a rarity. These days wholesalers work at the speed of city traders as calls come from home and abroad throughout the night and early morning.

Before the Channel Tunnel, deliveries of flowers to the Market from the Continent were restricted to two or three days per week, with top-ups from British growers, and our orders had to be placed weeks before we needed them. Nowadays you can email an order at Monday lunchtime and the flowers will be in the Market by dawn the following morning. Wholesalers work long, hard days, on their emails and phones all day. Starting work at 11pm and not finishing until noon the following day is not a career choice for the faint-hearted!

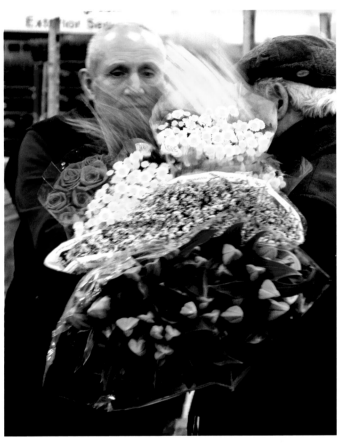

Some buyers, such as the couple on the right, appear
to enjoy the creative process on-the-hoof that the
Market affords, offering as it does such a spectacularly
varied smörgåsbord of flowers, foliage, plants and plant
materials from which to pick and choose, compare and
contrast. Other buyers are more urgent and impulsive,
(above) hastily filling their arms with their focused
floral needs, while imploring the ever-busy salesmen to
start writing out their dockets.

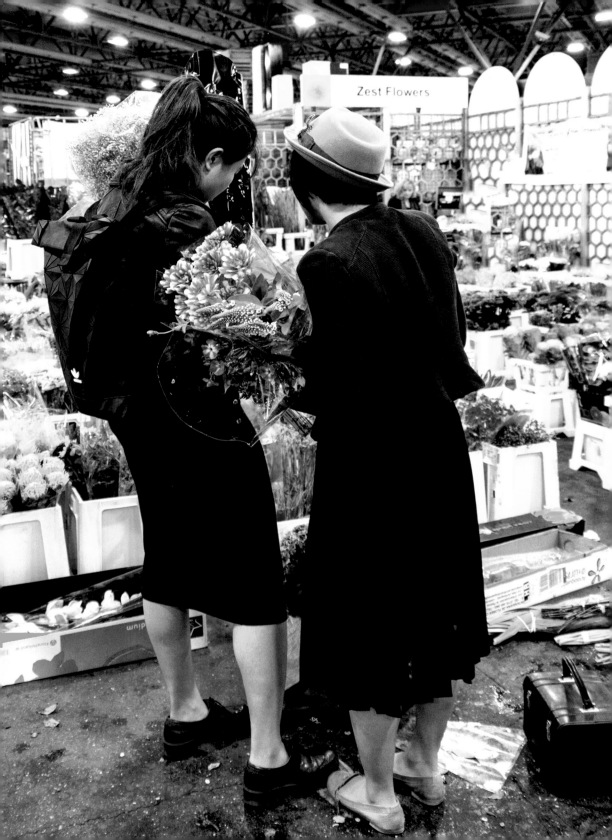

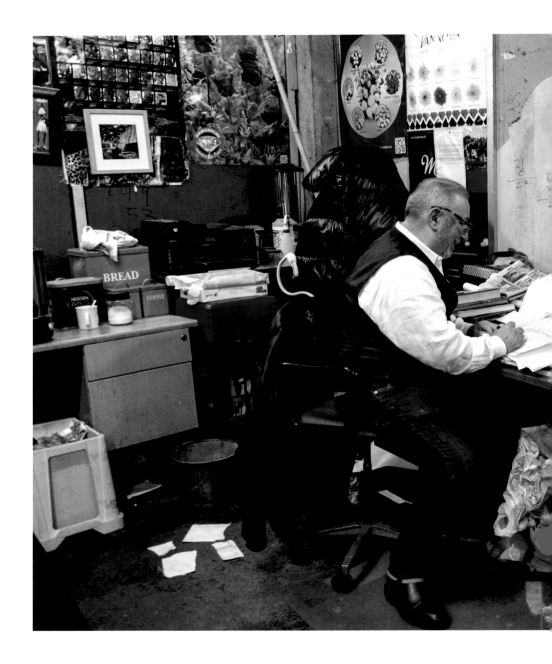

Most traders' hours are long and anti-social — in fact many spend longer at the Market than they do in their homes. One possbile reason why Dennis Edwards, a Market stallholder with too many years to count under his belt, has created a nest for himself, filled with the flotsam of a life spent selling flowers.

29

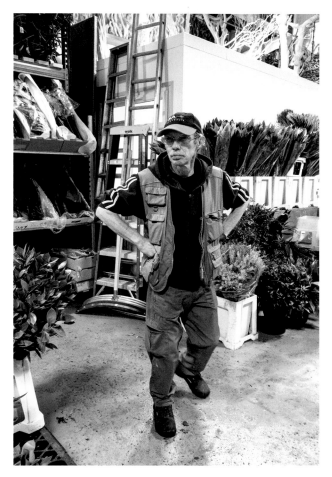

The huge demands the Market makes at busy times means that people who work there are often rushing, so it is hardly surprising some are always a blur! The porters develop a sixth sense for knowing where we florists have each been buying, relying on the salesmen to tip them off as to whether it's one or three boxes, or two or twenty buckets, that they need to collect.

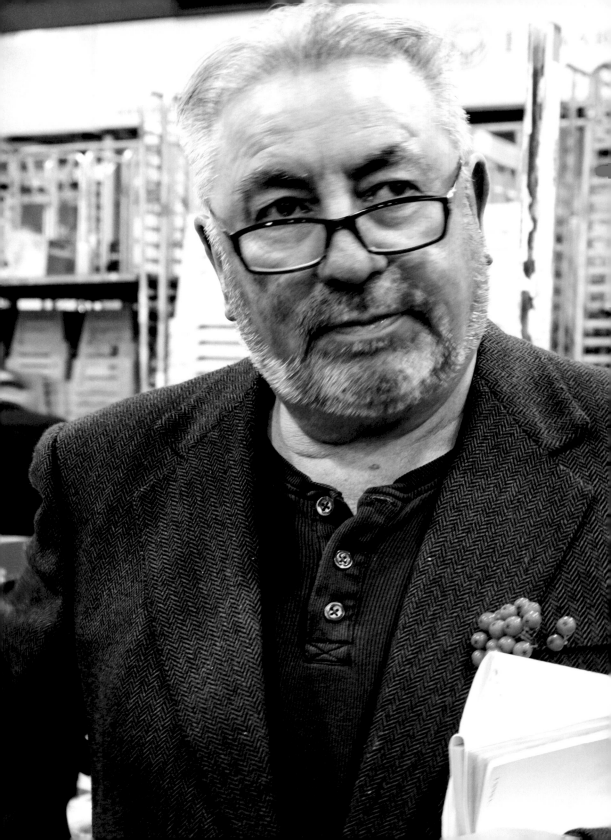

" *Fifty-four years is a long time but I've always enjoyed the banter with customers and colleagues. It's been a privilege and an honour to be trusted by the biggest names in the floristry business to provide flowers for events worldwide, and to be the first with anything new to the Market.* **"**

DENNIS EDWARDS
MARKET TRADER

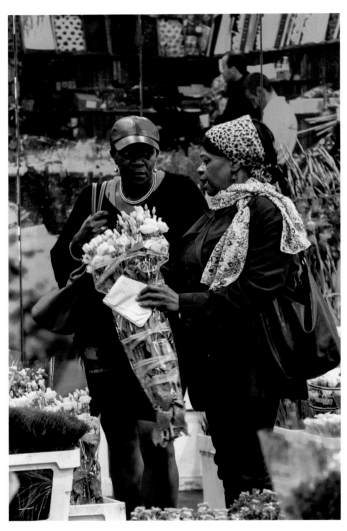

On busy spring and summer mornings, the Market fills with colour as the stands burst with buckets and boxes of blooms, and as regular buyers and 'odd marks' (as the one-off customers are quaintly termed) head to south London for the 'pick of the bunch'.

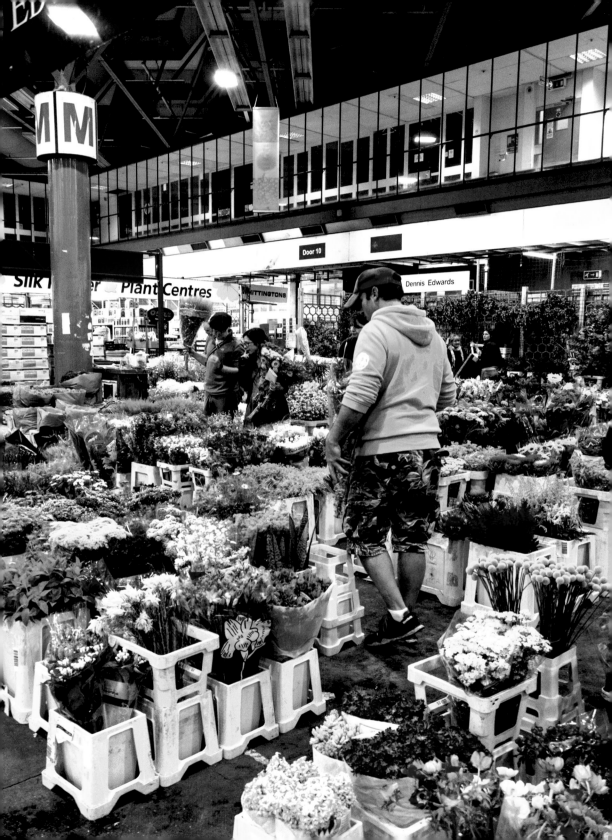

Visiting the Market as I do at least several times each week, I spend my time looking for new and interesting plant material (right), photographing them for future reference and chatting to suppliers about up-and-coming events and orders. You get some idea of the scale of our events when you see me wheeling this trolley laden with fabulously fragrant lily-of-the-valley destined for a wedding weekend.

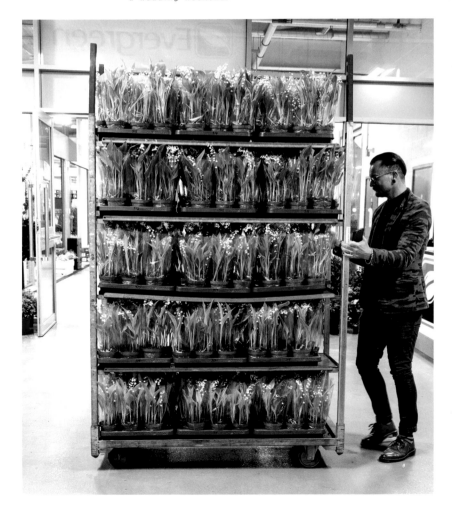

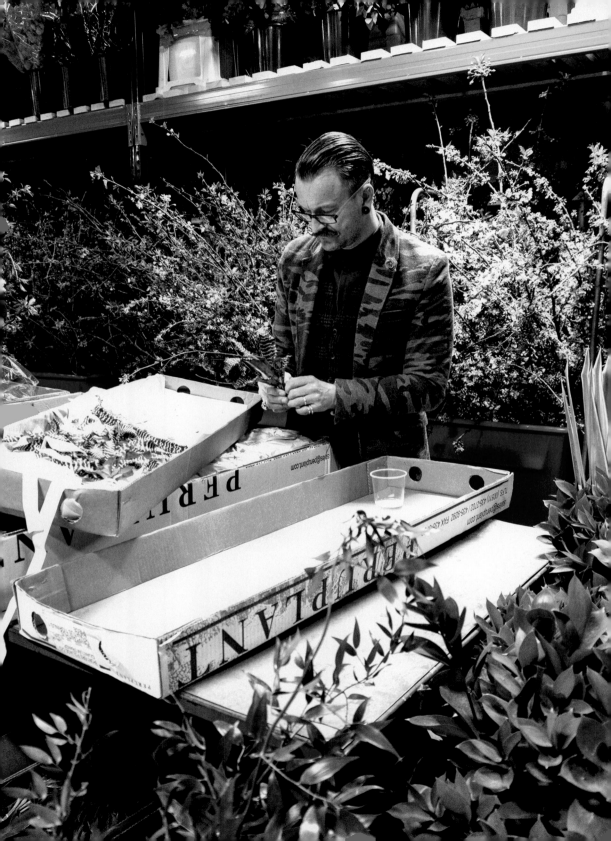

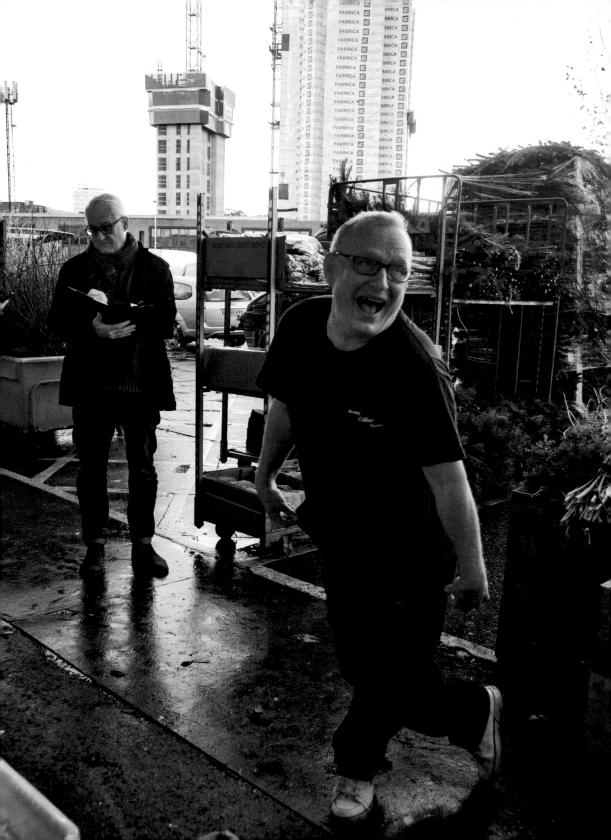

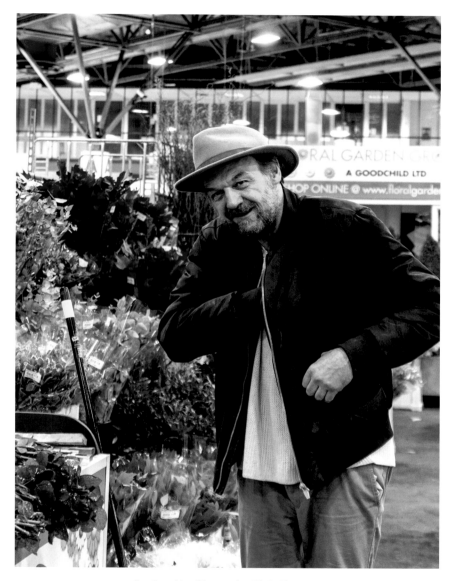

During the 12 months Michelle Garrett was capturing
an incredible array of brilliant images at the
Market, some of the regulars (left) were only too
happy to play up to the camera; others (above) were
a tad reticent!

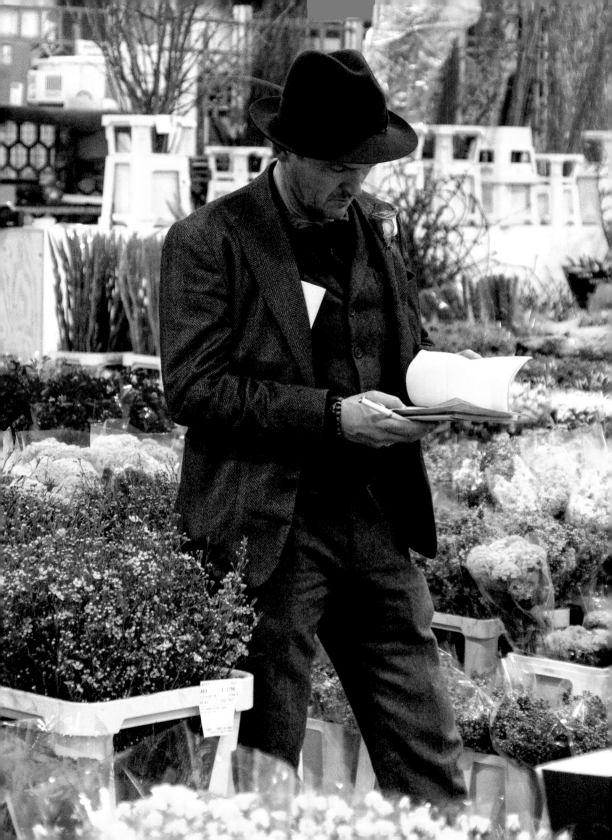

*From taking a few minutes reviewing the morning sales
or grabbing forty-winks, the men and women who work
at the Flower Market are on the go, and on their feet,
for up to ten hours a day, six days a week.*

The inimitable Henck Roling (left), a great florist and a real Market character, whose personal style is as flamboyantly fabulous as his floral decorations. And he has a 'tache to make me green with envy!

The porters at the Market (right) really do keep the wheels turning, moving boxes and trolleys laden with flowers to and from buyer's vans around the assorted stands.

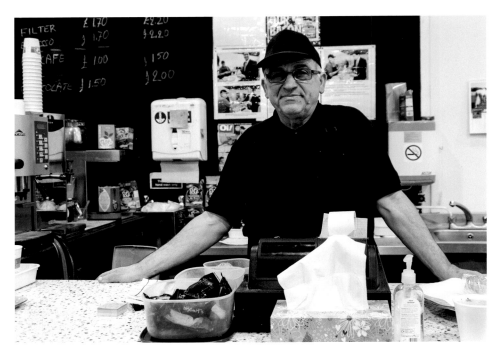

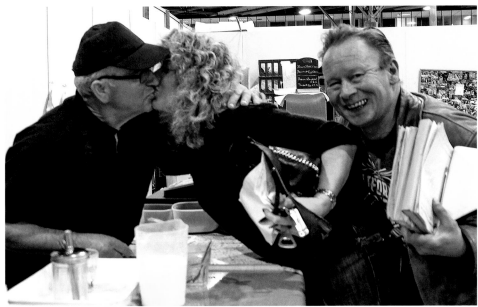

Without breaks for Tony the Tea Man's
cuppas, and the banter that goes
with it, working in the Market would
be that much harder.

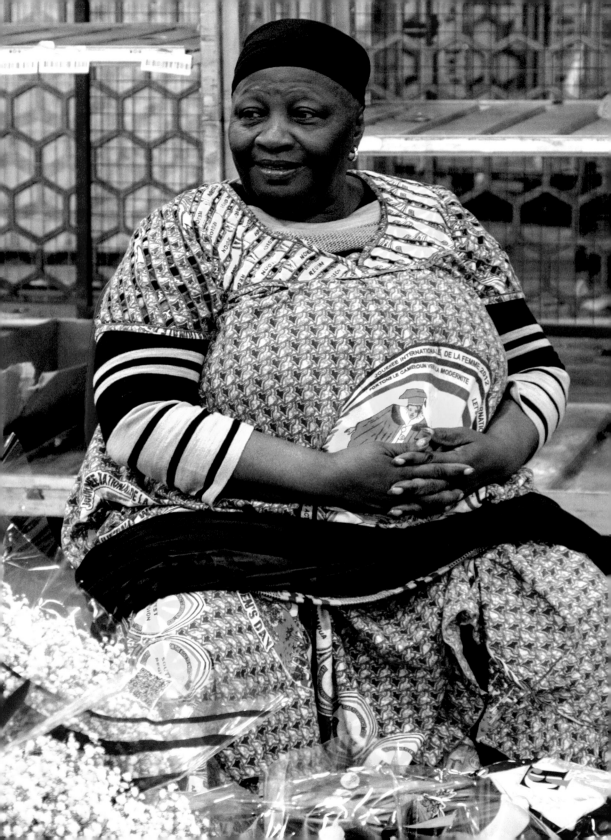

Towards the end of the day, sellers and purchasers relax, mission completed.

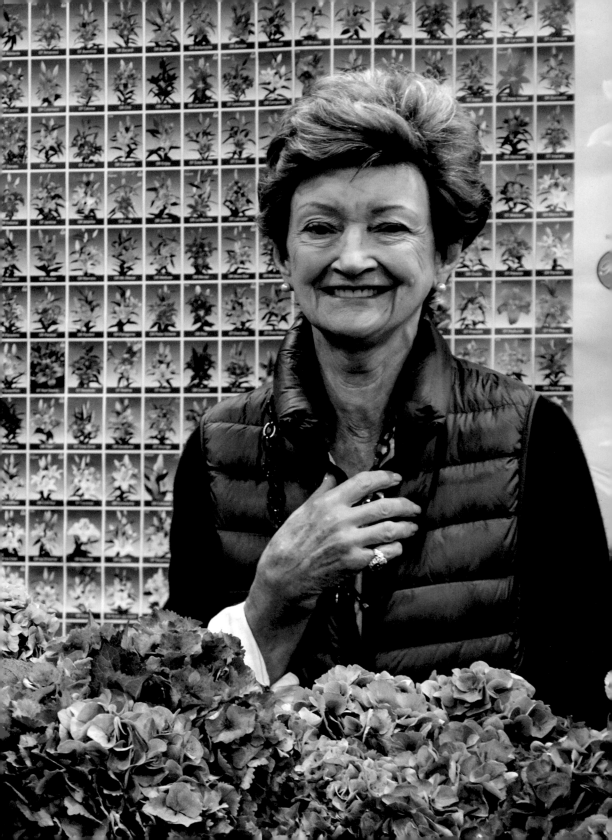

“ *Arriving at the Flower Market early in the morning is like entering a club. The people who work there make it a pleasure, always cheerful with a smile and a laugh. The flowers are a joy — colour, quality and fragrance. Over the years the varieties and availability has grown, with flowers flown in from around the world. The seasons bring excitement especially the first English-grown sweet peas, so fragile and fragrant, and then comes paeony heaven!* **”**

SONJA WAITES
FLORIST, PULBROOK & GOULD

flowers for all seasons

Across the year, the contents and the logistics of the Flower Market vary hugely, depending on what is in season. By March, tulips carpet the floor, arriving in large boxes from the British growers, and packed into shallow tubs from Holland. Each tub contains four paper wraps of tulips, each wrap holds 50 stems, so 200 stems in total. Spool on a few months and paeonies will be stars of the show, again arriving either by the British-grown box, packed five-to-the-bunch, or in Dutch buckets from Aalsmeer where bunches contain ten stems! The intricacies of flower selling are legion...

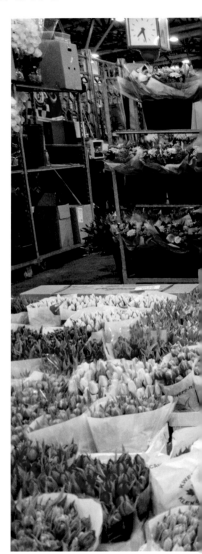

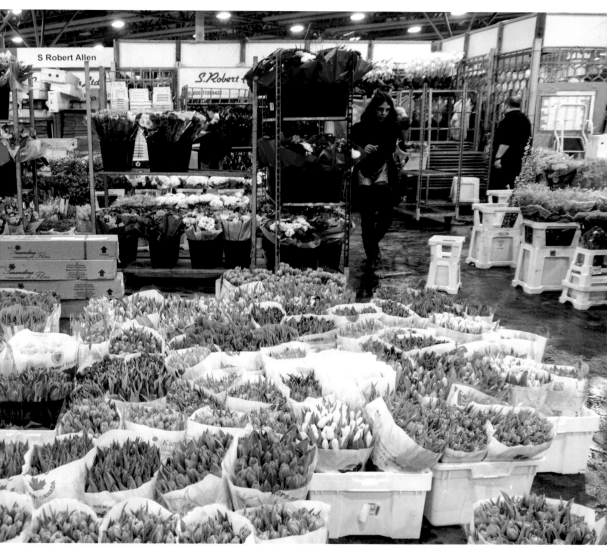

Buckets by the hundred, in characteristic 'hearing-aid'
beige, arrive loaded with flowers and, after unpacking,
are stacked onto trolleys to make the return trip to
the Dutch flower markets.

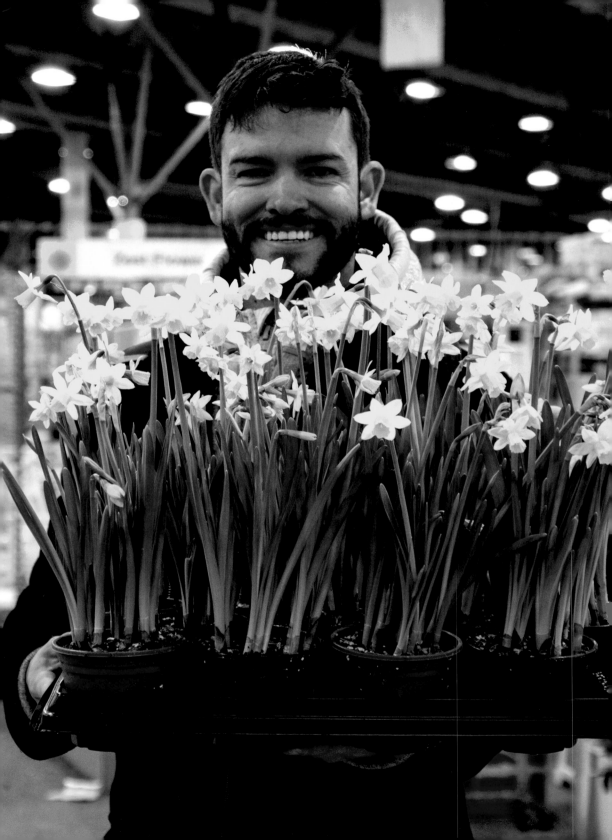

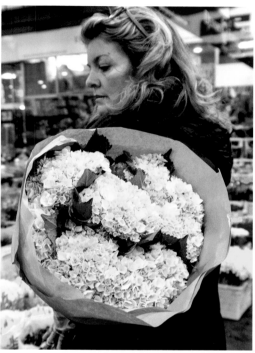

A great delight of the Market is that the
seasons can all be present in any one week,
if not in any one day. Even as narcissus and
daffodils are showing their cheerful sun-
shine-bright buds across the country, the
bundles of imported summer-shaded hydrangeas
are still available in the Market, making a
florist's life easier when coping with the
demands of out-of-season events.

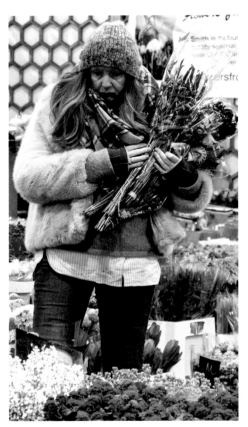

The reason why so many people who work
in the Market are wrapped up in layers of
coats and cardigans is because the Flower
Market is maintained at a constant (but
chilly) 14 degrees Celsius. This helps to
to prevent botrytis and limit the release
of ethylene, improving the life span of
fruit and flowers.

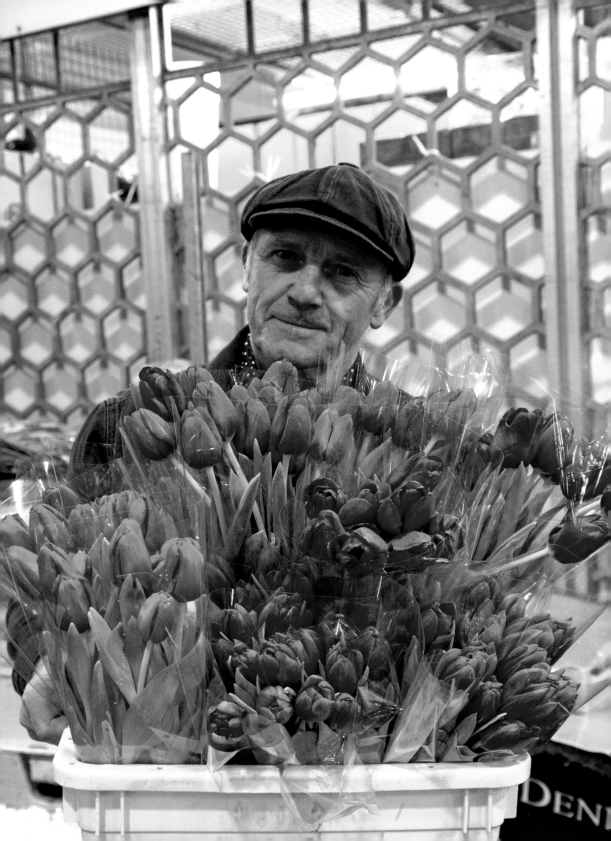

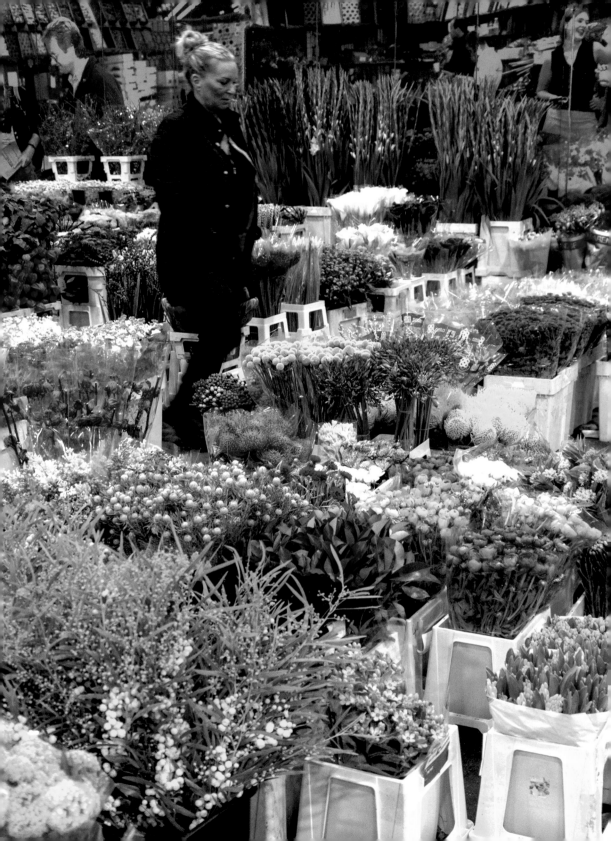

On any one day, the Market bursts with blooms and each
and every season flies its flowery flag. Springtime
stalwarts such as mimosa and ranunculus rub shoulders
with summery agapanthus and autumnal physalis. No
wonder some days newcomers and regulars alike look
spoiled for choice!

“ *I really love the fact*
that I haven't thought
about another job for, like,
37 years — that's a long
time for me... working in
the Flower Market with its
obvious vibrancy and wealth
of eclectic characters was
meant for me. I love it.
PS I obviously have no way of
proving this, but I'm fairly
certain that market has
made me much sexier too! **”**

MAURICE GILBEY
MARKET PORTER

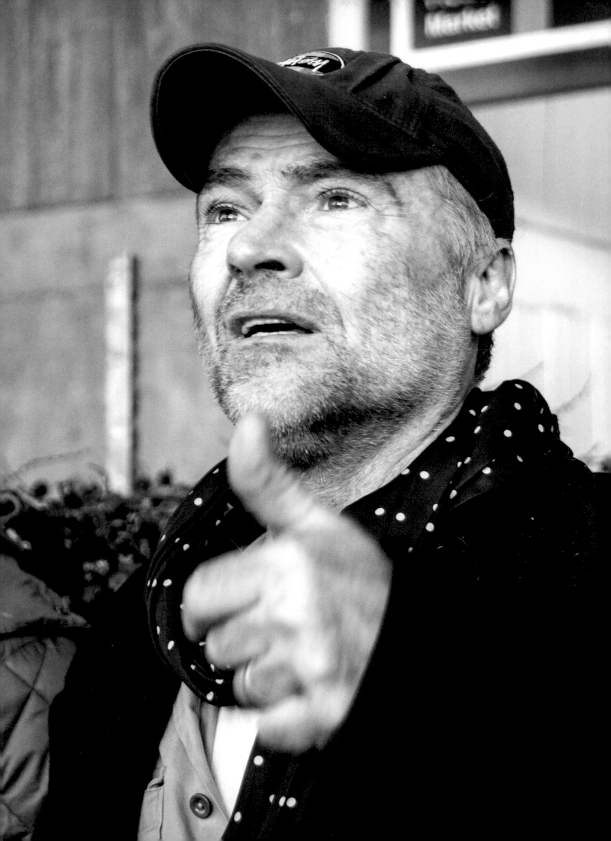

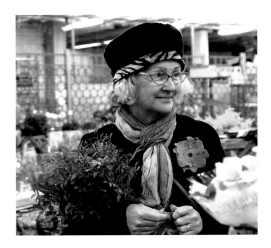

From armfuls of spring blooms to sheaves of autumnal nerines, bunches of blossom or palms by the foot, it's unlikely that anyone who visits the Market ever leaves empty-handed.

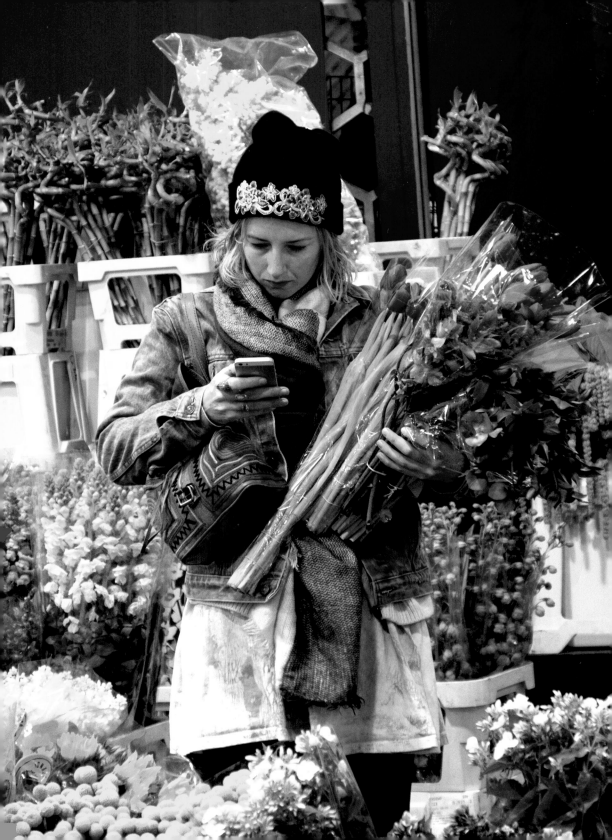

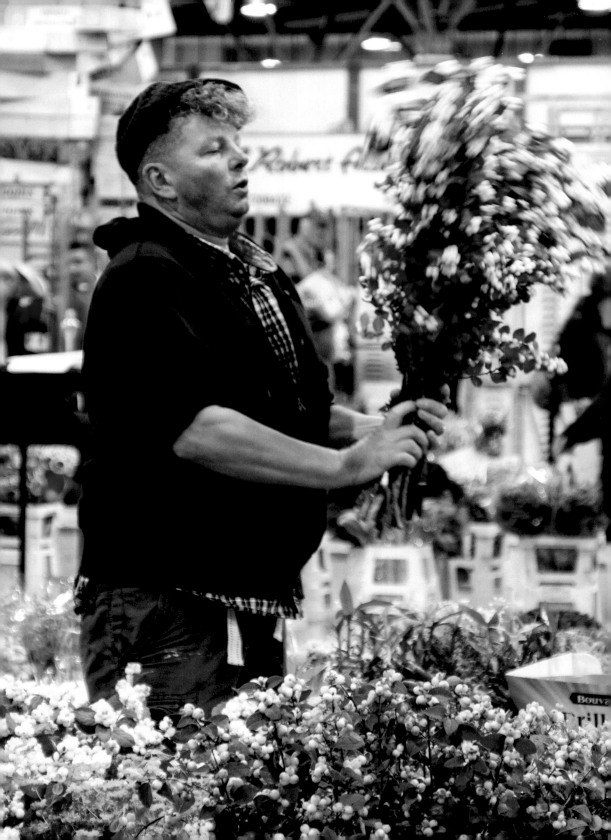

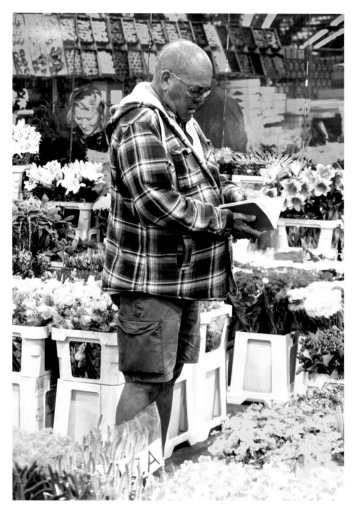

More regulars buyers at the Market... this time it is
Simon Townsend (left) whose glorious, traditional flower
stall is a fabulous feature of London's iconic Jermyn
Street, and Brian Whitaker (above) who for over 55 years
has been a buyer at the Market, loading his van each
day and distributing foliage plants and flowers to shops
across the city.

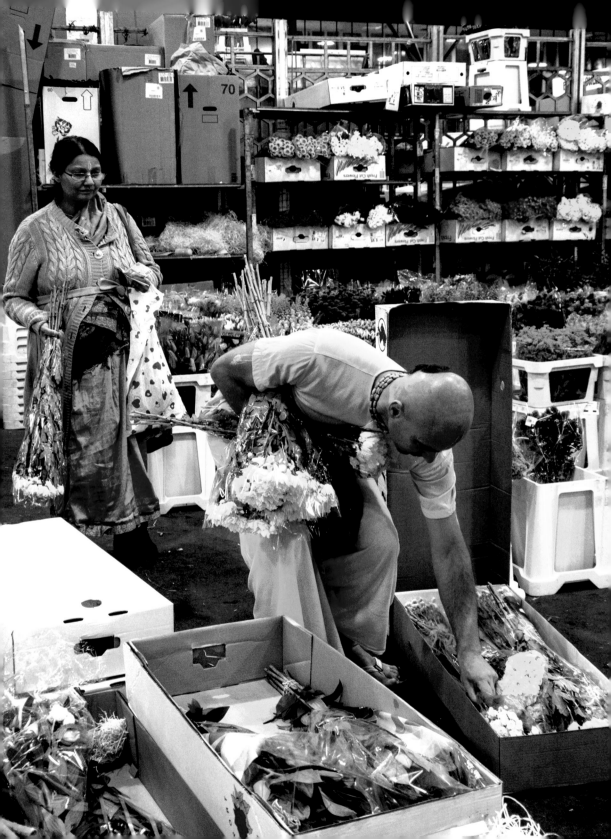

A marvellous melting-pot of cultures and creeds, and
of all ethnicities, the Market happily flowers all of
London. Adding a frequent and fabulous flash of orange,
Hare Krishna devotees are regulars at the Market,
selecting flowers to display in their temples and to
share amongst their communities.

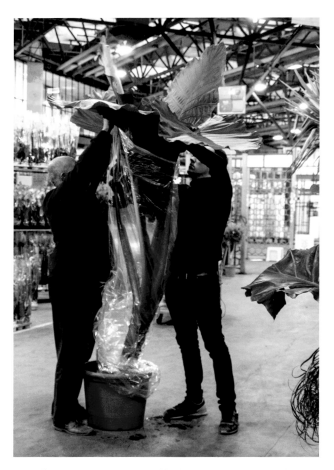

The Flower Market is not all flowers! It is a rich repository of plants, too, including spectacular specimens of some really exiting exotics — like the massive Alocasia these two are wrestling with (above). Not everything is as it seems either, as the image on the right features only the false and fake.

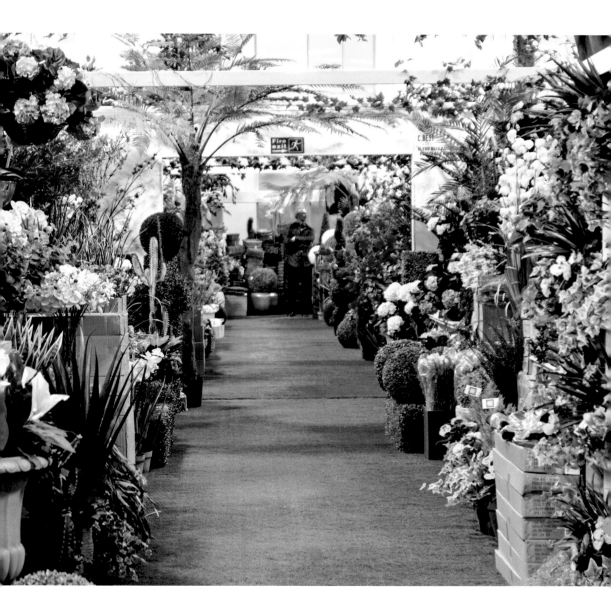

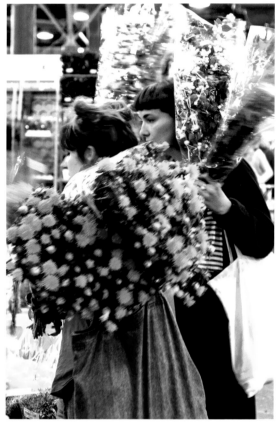

Apart from a few quiet start-of-the-year January
days, colour abounds at the Market. Not just
in the blooms and bunches on display, but in
the surprising and exciting combinations that
the buyers pick out for their daily decorative
selections. I think a gathering of florists
has to be one of the most magically colourful
groups anywhere — but especially at dawn in
south London! I wonder what the collective name
for florists should be? A bouquet….?

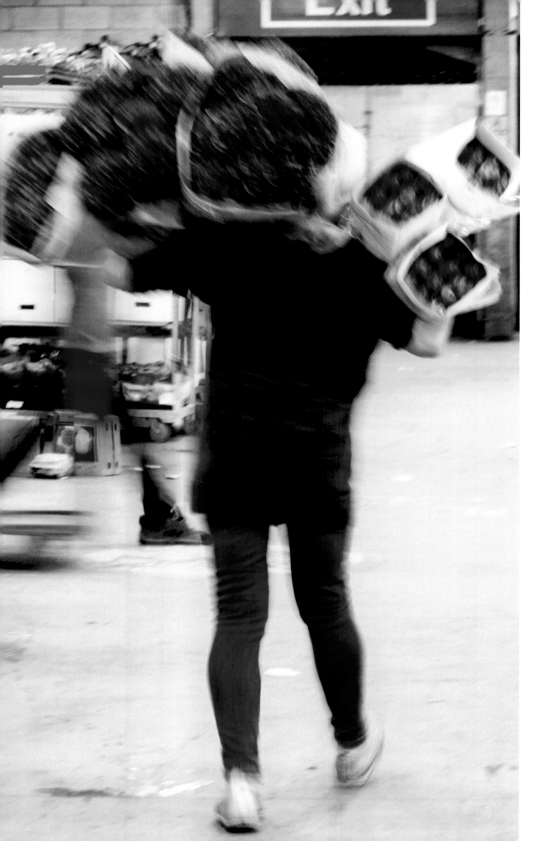

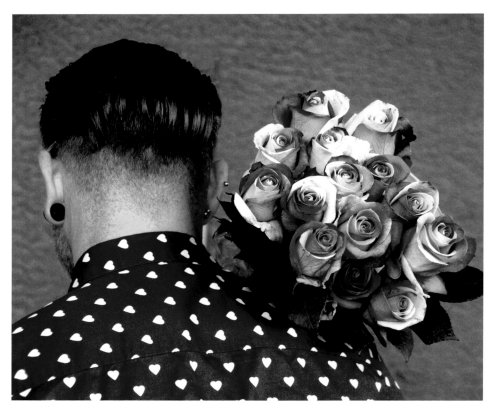

From the terrifically tonal and tasteful to the gloriously garish, the Market has it all! And these so-bad-they-are-good patriotically red, white and blue roses are always a show-stopper. Like my haircuts, not always a crowd-pleaser but unfailingly provoking comment!

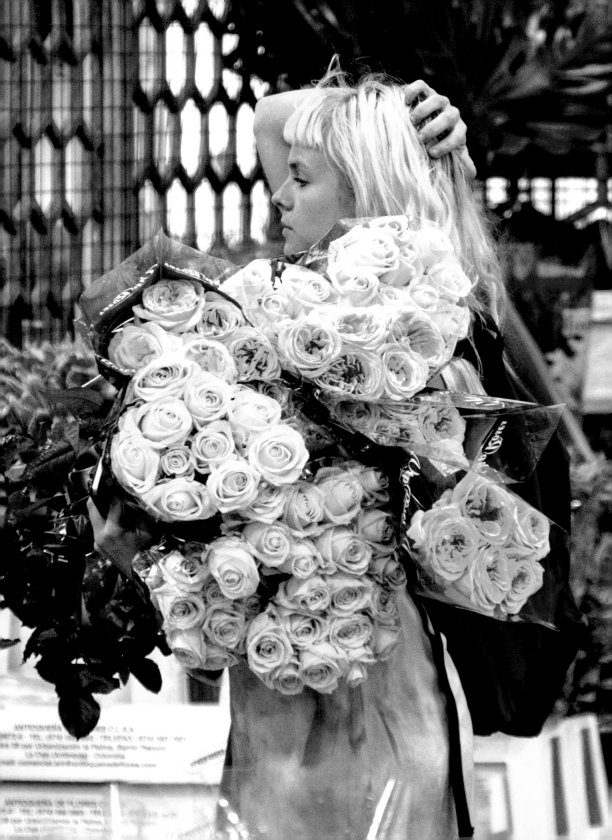

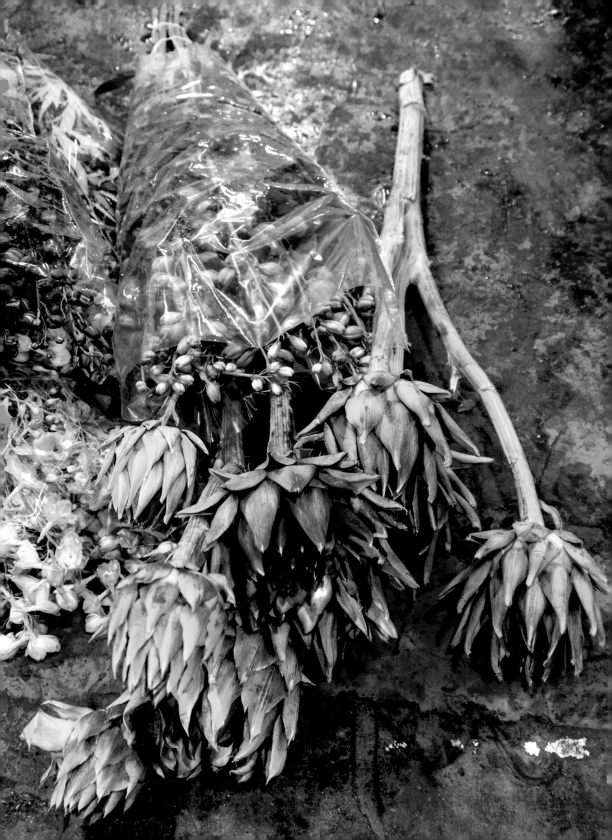

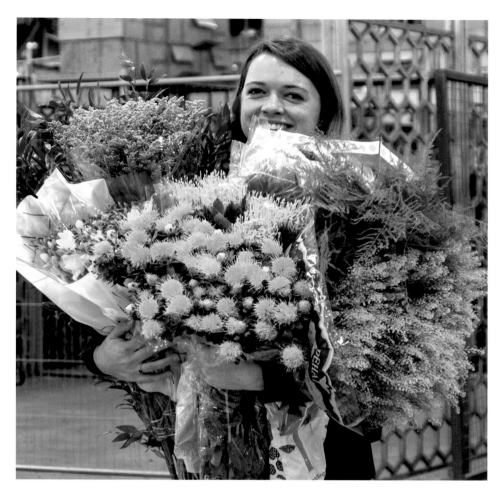

The textures and tones of foliage are as
eye-catching and as valuable to us florists
as the flowers, and the Market is almost
unique in its offering of stands that
specialize in greenery alone, gathered
from across the globe.

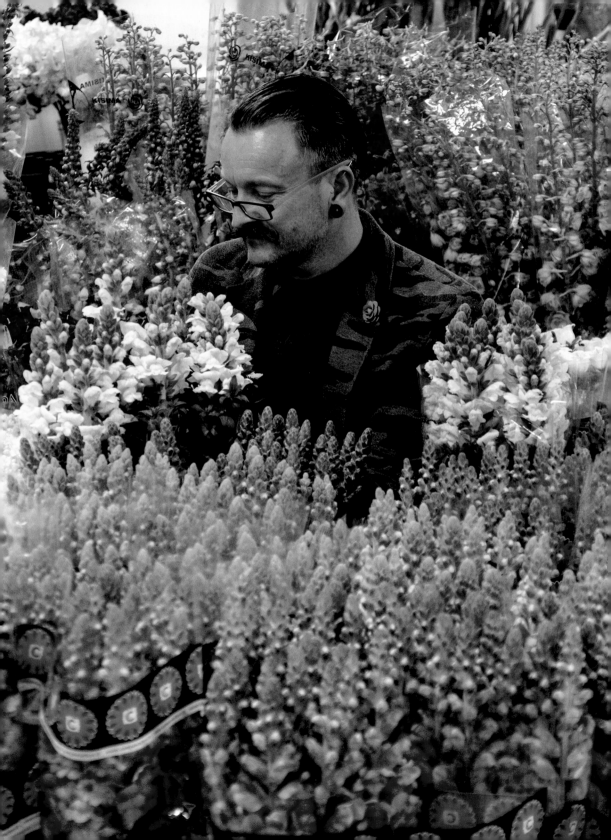

Every day, at every stand, and at every time of year, there are vistas to delight, such as the sea of soldier-straight antirrhinums in early summer (left), selling themselves by being just too beautiful to resist! Come early autumn, it's the turn of the first of the hop bines (right), fresh from the fields of Kent, to catch my eye, exuding their distinctive beer-breath tang on a chilly September morning.

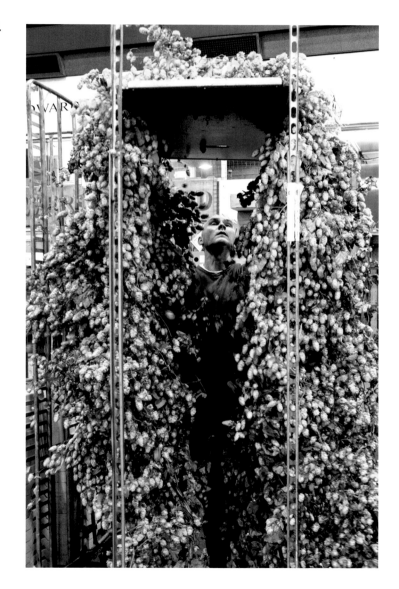

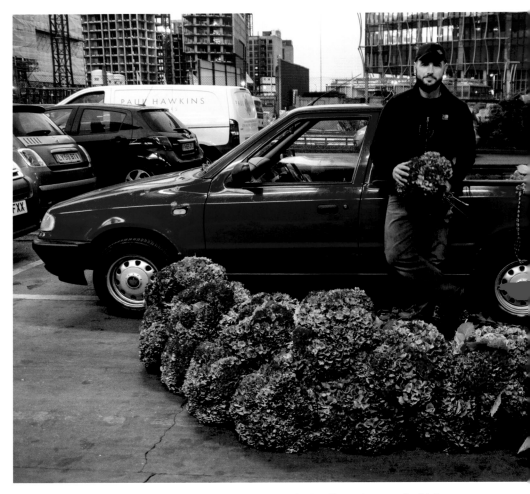

From the late summer until the first frosts, English hydrangeas fill the flower market, and their foamy florets in a palette of distressed and antique autumnal tints and tones are always in great demand. Gathered from Kentish gardens at first light, they are bunched, bundled and sold before the sun has brightened the strange cocoon-like covering of the newly constructed American Embassy in the background.

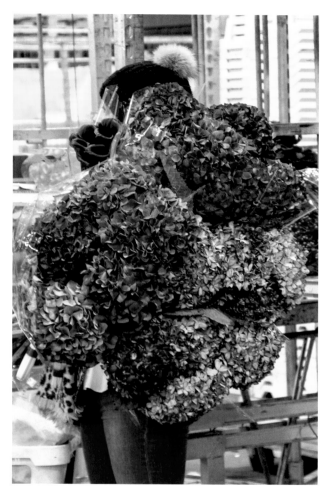

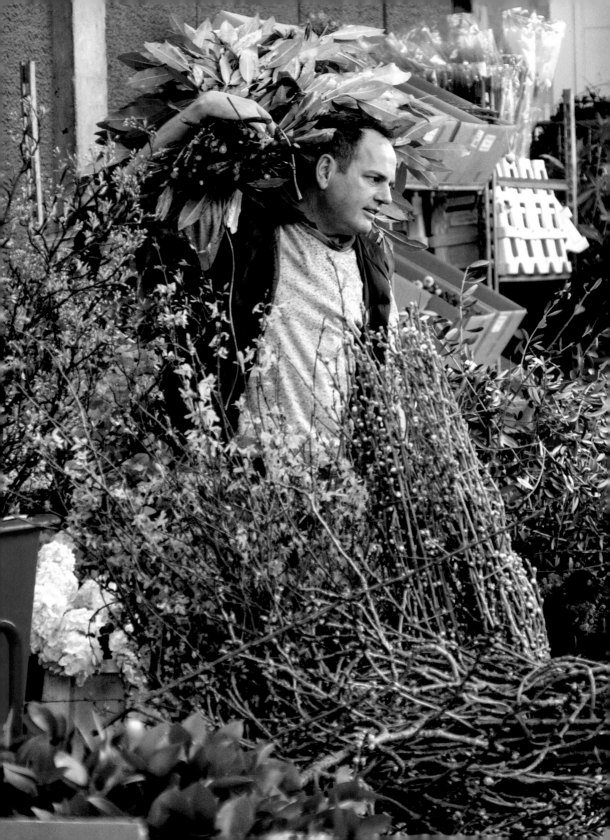

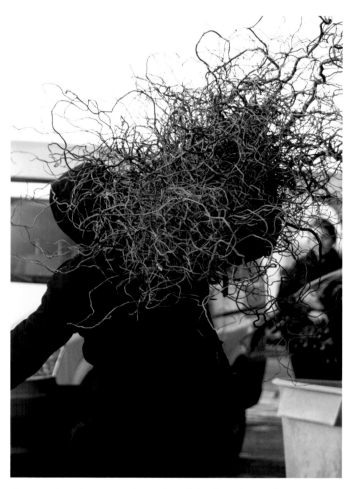

From sacks of moss and stacks of bark, slices of tree
trunks and crates of pine cones to bunches of berries
and bundles of branches, the stands of the foliage
wholesalers are a unique treat within the Market. Always
laden with photogenic logs, the loveliest of lichens and
larch, they are also the repository of the heaviest and
the most user-unfriendly foliage, with prickly thorn-
encrusted leaves, and huge boxes of exotics from
far-flung places. The guys and girls who serve and
sell at these stands are the most stoic of all.

❝ The buzz of the buyers, and the mix of foliage we get in makes this place different every day. I love the fact we specialize in selling British and seasonal foliage. It's always changing, which is always interesting — almost as interesting as the customers! ❞

ADIL BOULAHRI
FOLIAGE SALESMAN

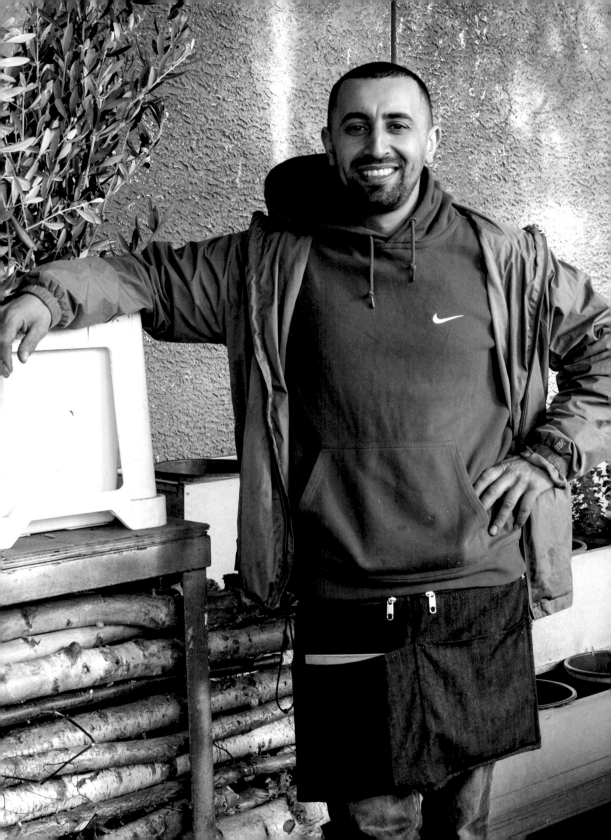

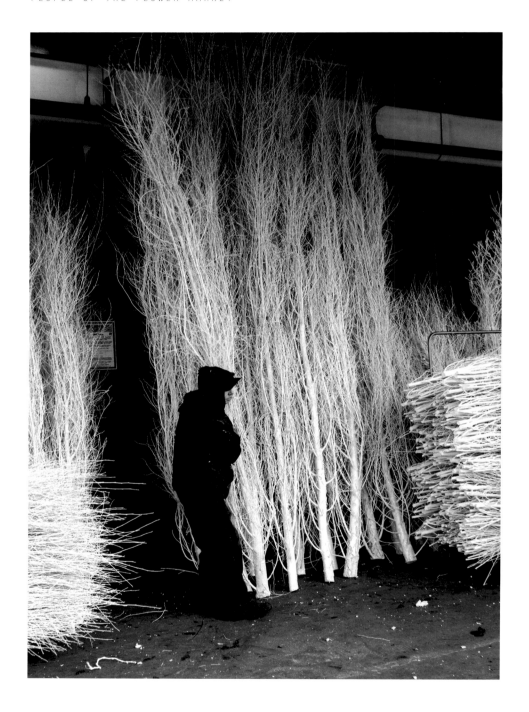

There are barely six months across the Market's year when there isn't at least a hint of Christmas rearing its glittery head! During the months of June and July, sad and sorry summer-growth-covered pine trees appear, only to be tortured into festive fettle for photoshoots and product launches. From October onwards, summer swiftly becomes a distant memory, as boxes of baubles and pallets of pumpkins vie for space within the loading bays. The orange-fest of Halloween is but a brief respite before the entire Market becomes immersed in all things sparkly. Christmas takes over and gradually the gangways become glitter-strewn. Bunches and bundles of twigs and of trees arrive, lacquered and laden with faux frost and saturated in sparkling sequins. The poor salesmen and women

who daily deal with such towering trees pretty soon become as glitter-encrusted as any bauble.

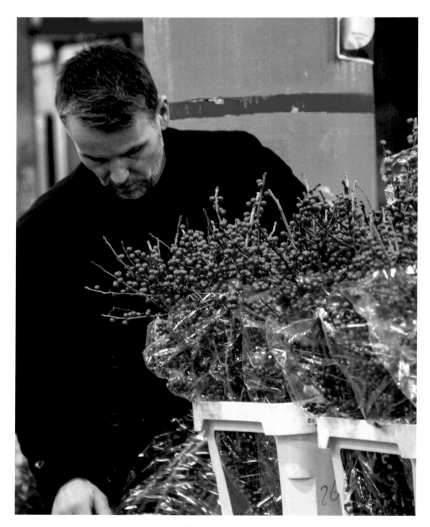

*Close of play at the Market leaves only
a ghost of the frenzied activity just a
matter of hours earller...*

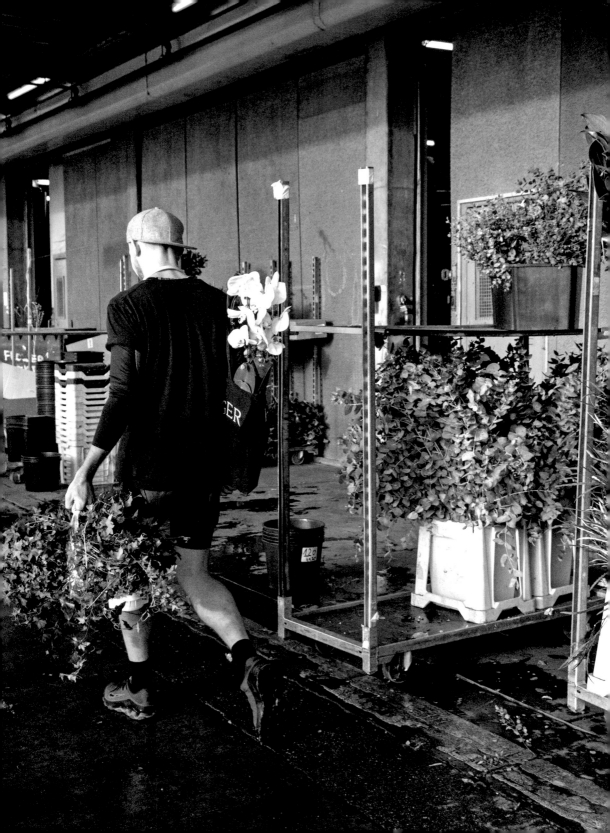

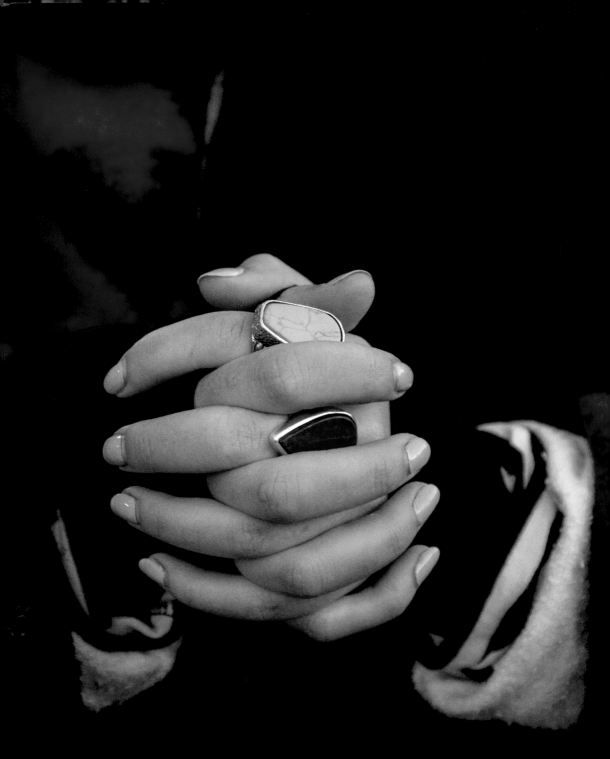

market fashions

The Flower Market has always been a brilliant
repository for the bold and the beautiful, with some
of the wholesalers as fabulously flamboyant as the
flowers they are selling! The customers add to the
lively landscape, and many are identified by the kick
of colour in their hair or a flash of fancy footwear.
Nothing is more uplifting on a drab November
morning than bumping into one these buyers, feasting
my eyes upon their attire and marvelling at their
elegant eccentricities!

I love looking at people's
hands as they tell you
so much about their
character or the work
they do. I enjoy the way,
too, some of them jazz
up their rather workworn
fingers, either with
bright blingy rings and
bangles or a coat or two
of outrageous colour on
the nails. Sometimes both!

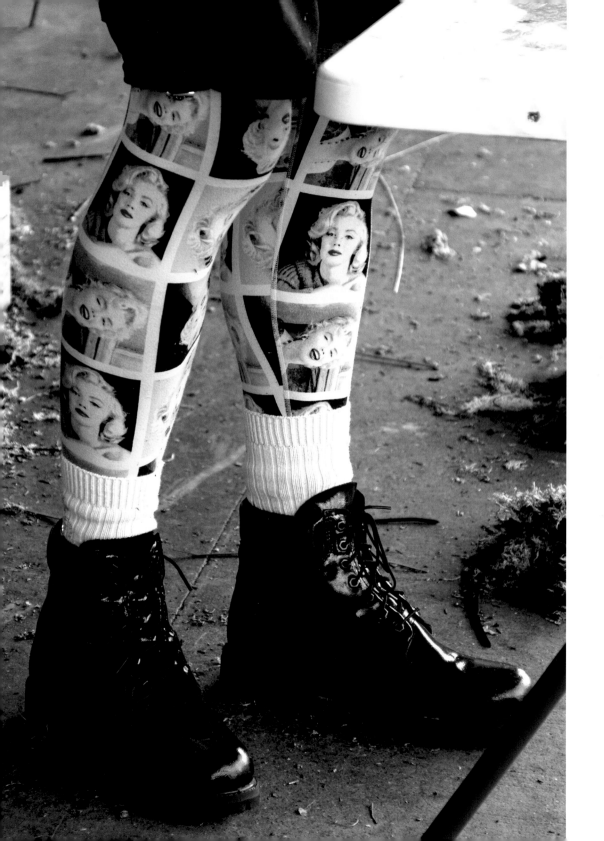

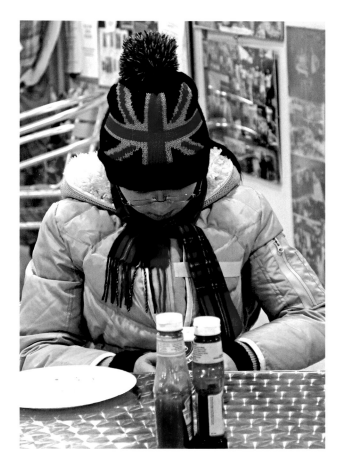

You can find people at the Market who stand out from the crowd wihout even trying, from the Marilyn Monroe printed legwarmers of a male customer to the firmly patriotic headgear and footwear of two other Market visitors.

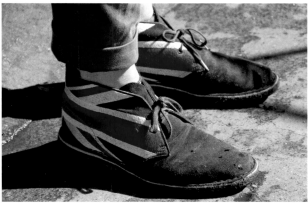

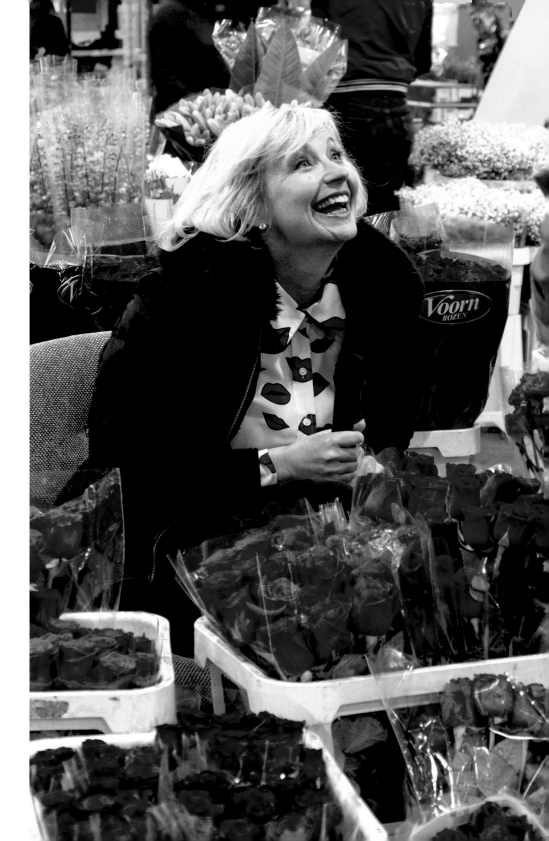

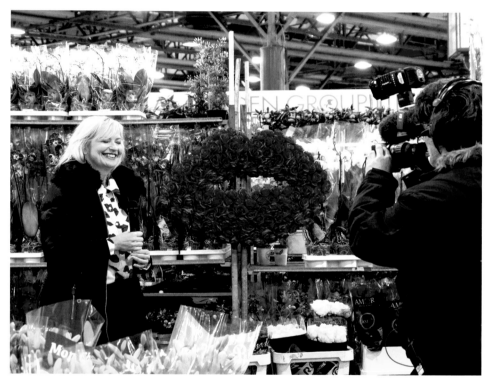

It is not just exotic and unexpected flowers
and plants that have the potential to add
a spot of spice to early mornings at New
Covent Garden Flower Market. The ever-
glamorous Carol Kirkwood — stalwart of BBC
Breakfast TV — is here spotted early on St
Valentine's Day, broadcasting live amongst
the red roses.

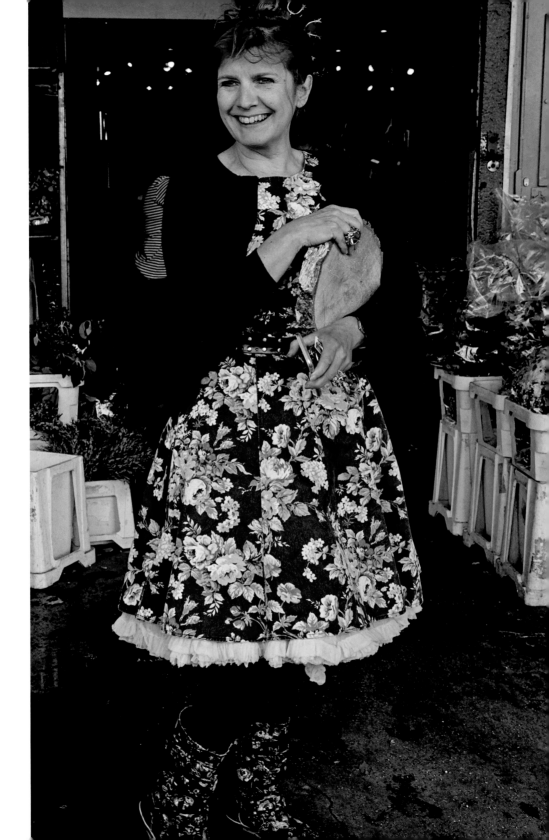

The exuberant, flamboyantly fabulous Athena Duncan, left, who, together with Mairead Curtin, are florists Rebel Rebel. Athena always brings a smile to my face, her cheery disposition only outshone by her outfits. Stalwarts of the Market, Athena and Mairead are uber-talented florists who daily buy beautiful blooms.

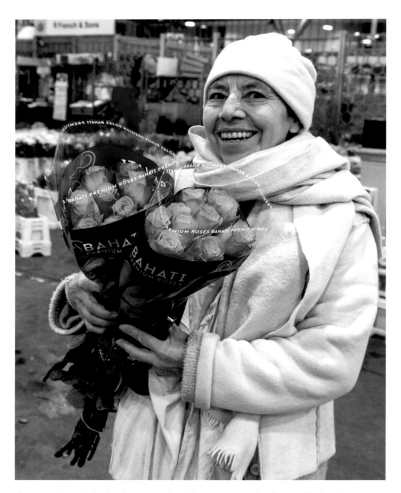

From understated elegance to the spectacularly styled, it never ceases to delight me when, at some early hour on a chilly morning, my eyes alight upon a real 'character' among the busy buyers who descend on Nine Elms in South London. As someone who enjoys having fun with clothes and with colour, I always appreciate the extra effort that has gone into working out what to wear, and never more so considering the antisocial hour at which it has happened.

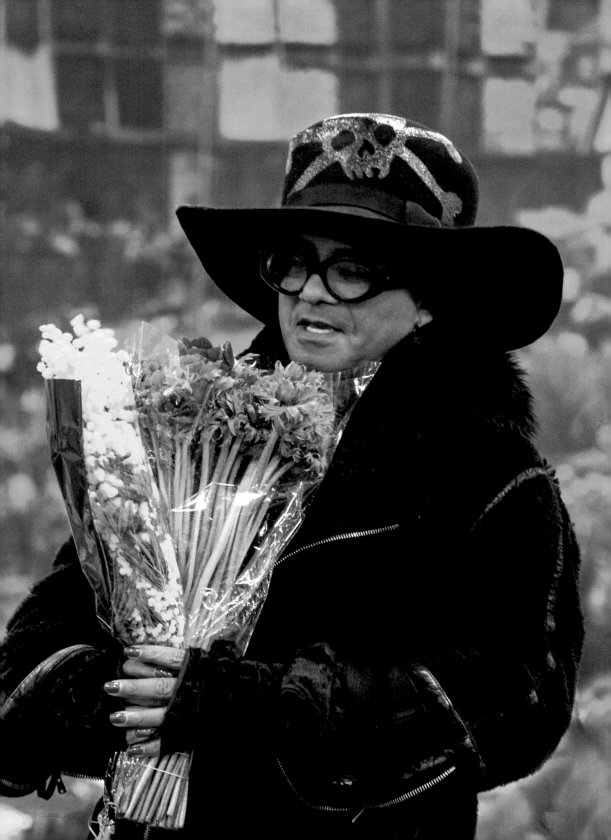

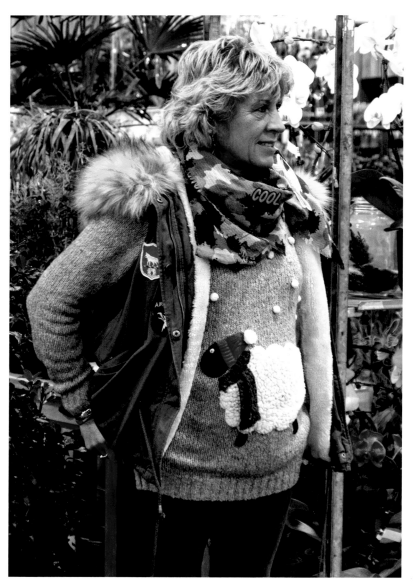

From joyous Christmas jumpers to proudly paraded new ink, the melting-pot of folk within the flower market are certainly never dull, no matter how early, busy, cold or quiet the day!

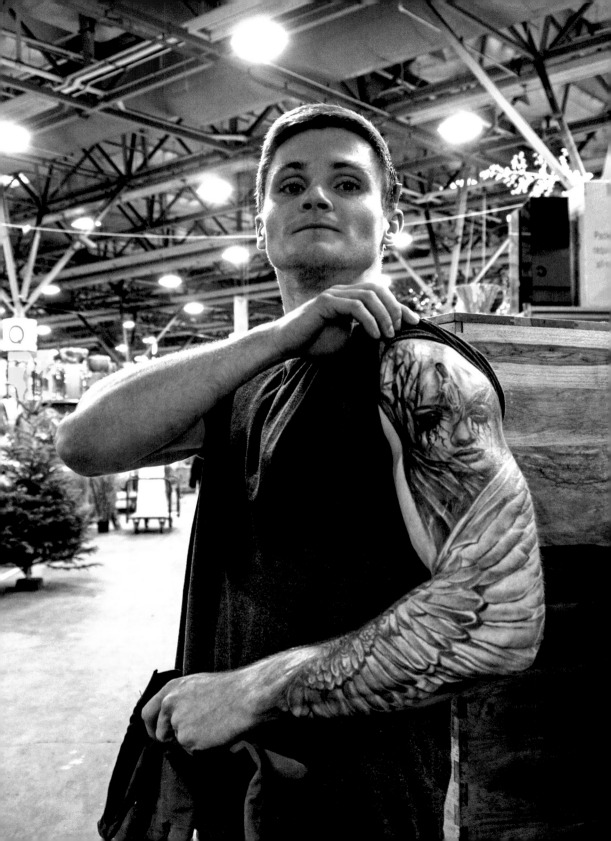

" We come to New Covent Garden because we love it! The flowers, the foliage, and the people. We're here at the crack of dawn in the height of summer for British flowers when competition for garden roses, geranium and cosmos is at its fiercest and, in the depths of winter, to find that perfect branch of lichen-dappled pear tree or soft pine. We've always loved the Market even when we first started and knew no-one but were quickly taken under the wing of lovely Eric from John Austin & Co, who showed us the ropes and didn't laugh at us too much! "

ATHENA DUNCAN
FLORIST, REBEL REBEL

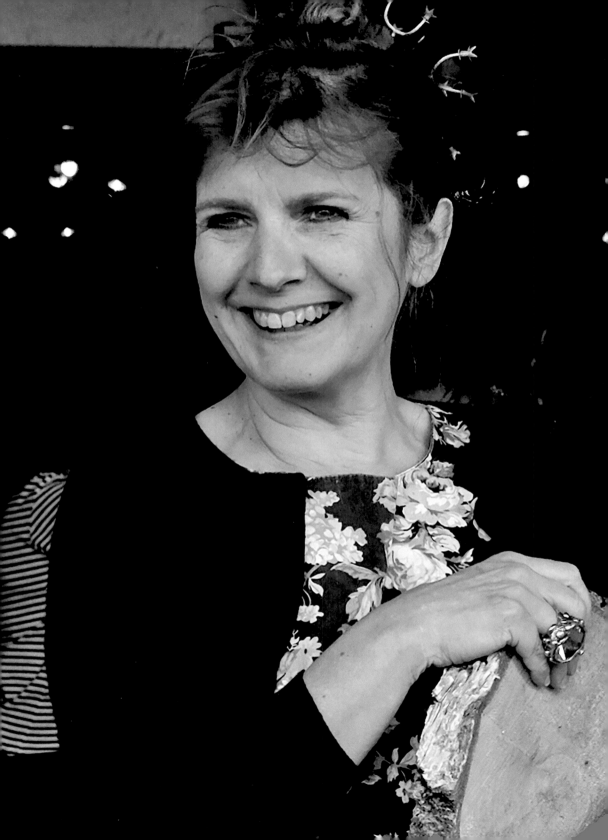

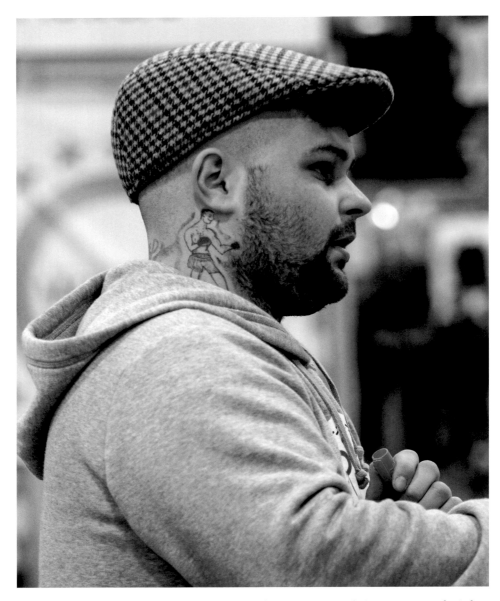

*It doesn't matter who you are, or what your personal style,
the traders at the Market treat everyone in the same
straightforward and down-to-earth manner — a healthy and
honest environment and a brilliant leveller!*

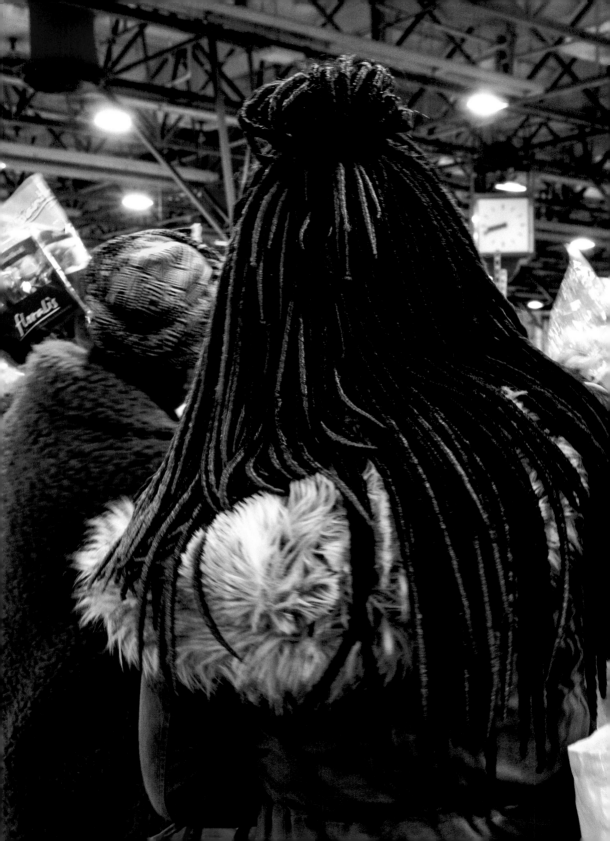

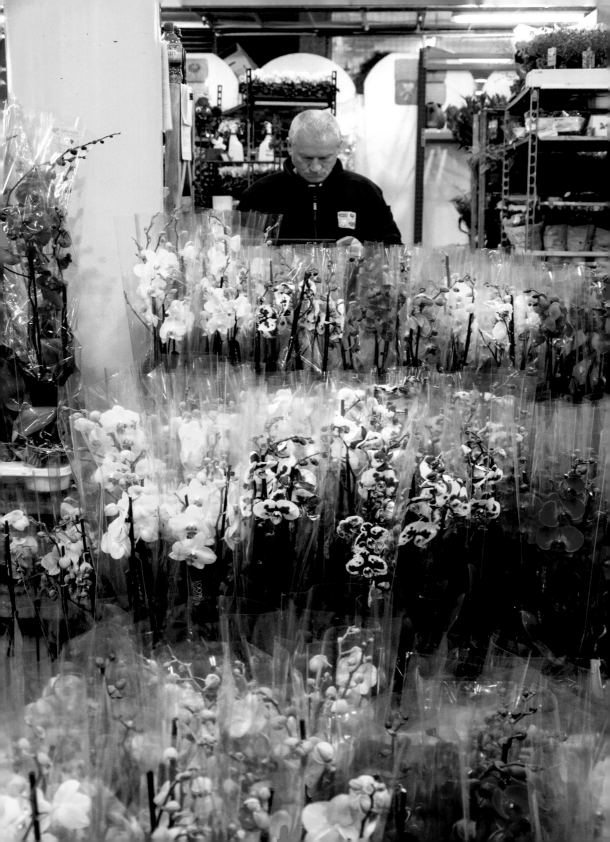

Orchids and hair in perfect synergistic harmony!

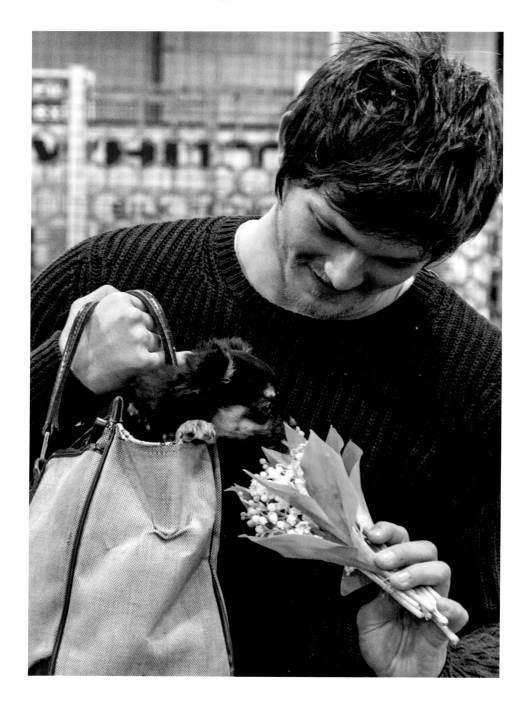

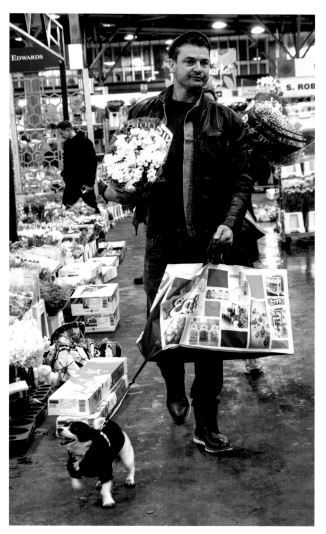

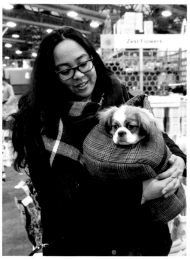

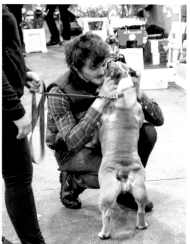

And pampered pooches get to sniff around the delights of the Market!

the not-so-festive season!

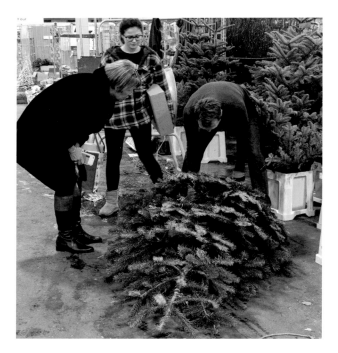

While Christmas is a magical time for most of us, for many at the Market it's a two-month-long trial. Pallet after pallet of wreath frames, bundle upon bundle of glittered branches or truck-loads of resin-oozing pine trees all need to be unloaded, sifted, sorted and sold.

At any time the work here is physically demanding, but as Christmas approaches the guys (and they are all men in the pine-tree department) have to dig deep into their reserves of strength and endurance, while maintaining a smile as yet another fussy florist inspects the umpteenth tree, requests it to be unwrapped, held upright for appraisal and seen from all angles to confirm that it is perfect and flawless.

Bagged and bundled, netted Christmas trees fill the market in November and December. Looking like vast piney Zeppelins in a myriad sizes, all of them are cumbersome and surprisingly heavy.

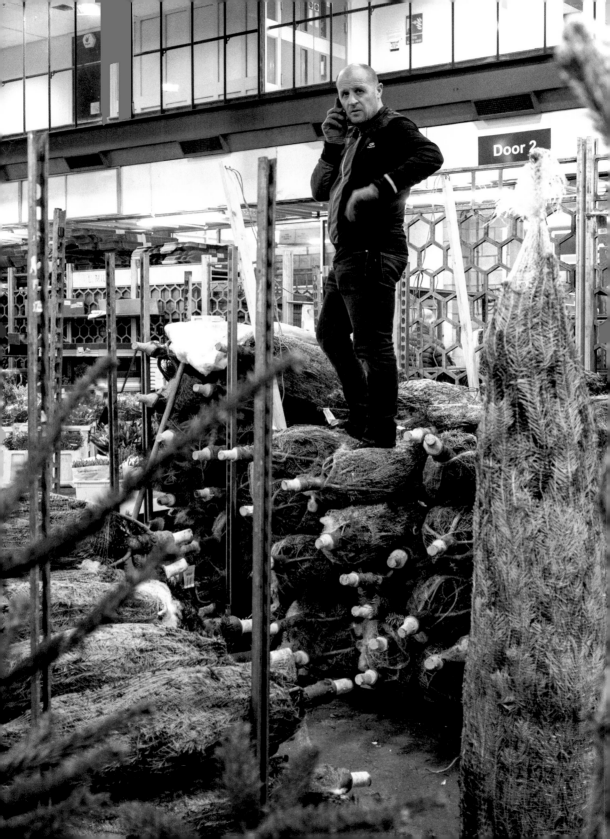

Christmas in the world of retail, and for most florists, is a frenetic two months filled with glitter, gilding, bruised hands and holly! Long hours and demanding clients as well as cold, dark mornings mean that most florists are a blur as we race around the Flower Market grabbing the pick of the bunch.

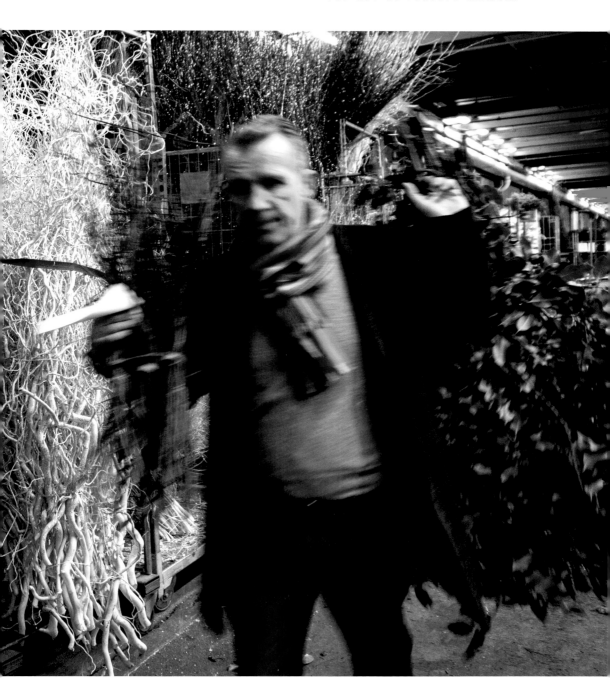

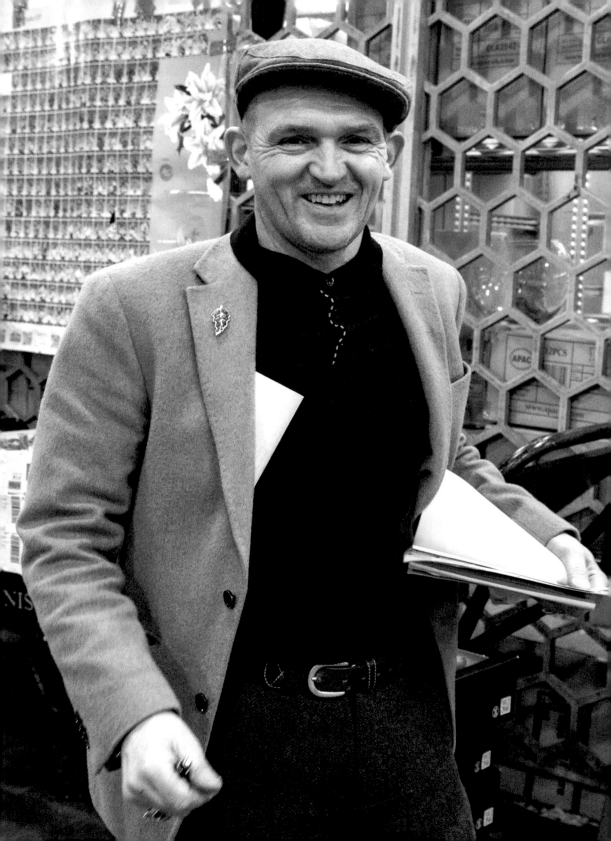

*66 From the very first day in
1970 that I went to market
with my dad, I loved it so
much that I left school at 14
in 1980 and became a junior
salesman. Along my journey
I have met and spoken
to wonderful people and
without them I wouldn't be
the person I am today. 99*

EDDIE MARTIN
MARKET TRADER

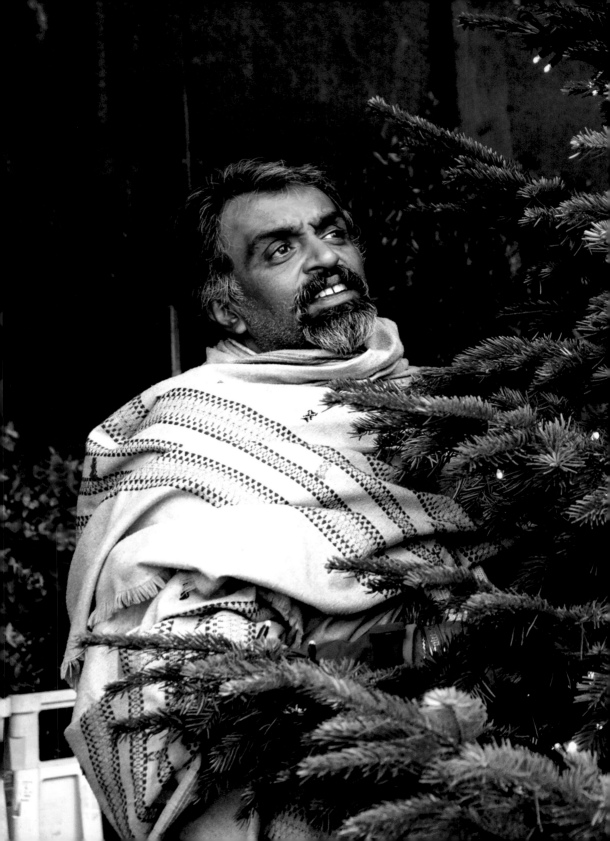

close of play

Those who work within the Market live a strange semi-nocturnal existence, as many start arriving for work before midnight, and most don't head home until at least 10am. In fact the fruit, vegetable and flower markets of London (and those few wholesale markets that exist across the country) are one of the last bastions of traditional night-shifts, where men and women set off to work as most of us are returning. It isn't a career that suits everyone, but those who take to it seem wedded to it as a way of life. Thank goodness there are still those who don't choose a 9-5 existence, as I, for one, don't relish the online alternative which some florists now use to purchase their flowers and supplies. I want to chat to the wholesalers, I need to be able to touch, feel and smell the flowers and foliage. I become excited as my nose sniffs out the first bunches of sweet peas, and my eye falls upon the early buckets of English lavender or dahlias or paeonies. And so I am deeply grateful to all of those who work so very hard at the flowery coalface, keeping me and countless other fussy florists happy, going the extra mile, helping to make our work wonderful! As I head back to Lycett Towers around 8am, there are still many buckets of flowers to be sold, many boxes of blooms to unpack, or to load, and so the hard physical labour that accompanies the purveying of such beautiful raw materials continues for another few hours.

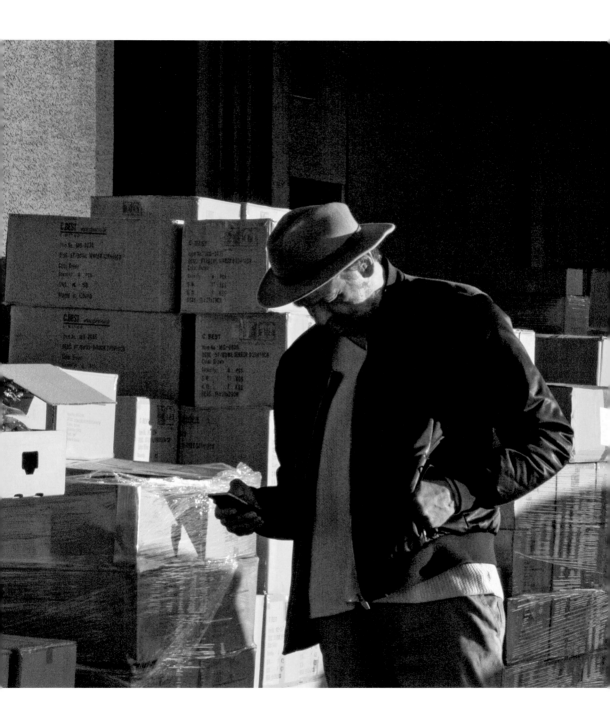

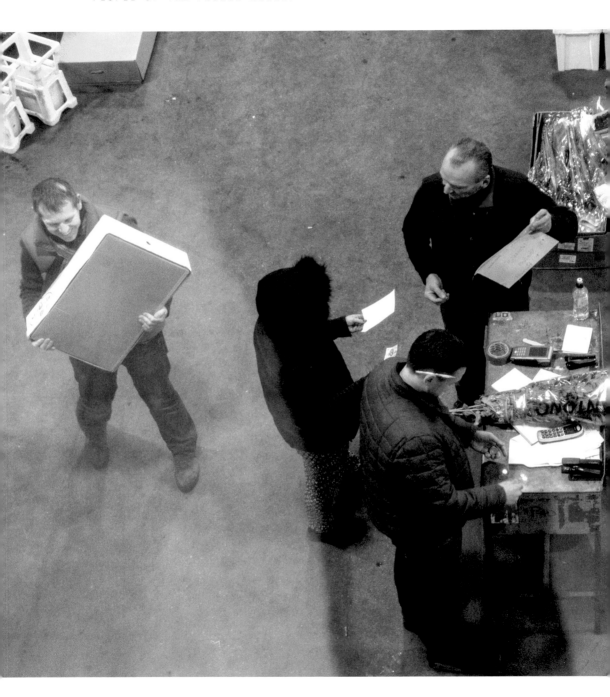

It is every trader's aim and intention to sell as much as possible as early as possible. Trading hours start from around 4am onwards, with the stalwart buyers arriving from 5.30am. By 8.30am most daily business will have been done. This gives the salesmen the opportunity to review the day's takings and assess what flowers, plants and foliage they have remaining, to begin focusing on future orders and catching up with one another. It's extraordinary how the colour-filled buying floor gradually changes back to the drear of empty buckets and concrete flooring.

The Flower Market is a bit of a dinosaur, with many
wholesalers still choosing to write all receipts long-
hand, in triplicate docket books, necessitating a whole
sheaf of illegible carbon copies to be deciphered later
by the poor souls working in accounts departments across
London and the south of England.

a fond farewell...

On March 31, 2017, the bell at Covent Garden Flower Market was rung for the last time to mark the cessation of trading on a site occupied since the 1960s. A vast and rather tired building with temperamental doors, a grotty café and terrible loos, and no air conditioning, it has nevertheless been a place I grew to love over 30 years of buying flowers there, but as much for its people as for the flowers

Some in this photograph, taken on the last day at that site, have worked alongside me, a few have been my boss, and many have sold me plants, sundries, pots and flowers for longer than I can recall. Through industrial unrest and economic uncertainty, the building, and the people in it, have been the constant. As the seasons rolled ever onwards and the years gently ticked by, the familiar faces have greeted me each morning, and I them in turn.

We have grown to know one another's foibles, learning about each other's characters as ours, too, have grown and developed. We have woven one another into our daily lives, and, across the years, these threads have grown strong and steadfast, supporting and sustaining, sharing a love for each other and for the flowers bought and sold there.

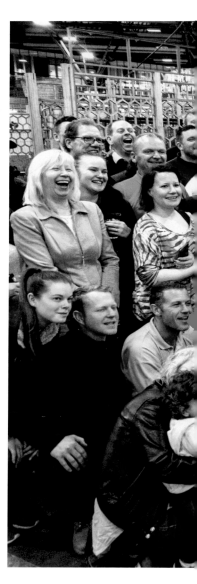

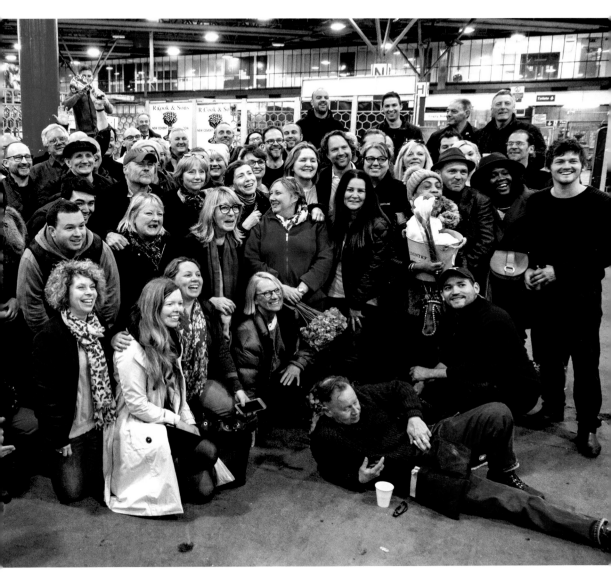

Now, as I write, the brand new New Covent Garden Flower Market is fully functioning, and in it are many of the familiar faces, as comforting to see each day as the bunches of beautiful blooms they sell or seek. And among them I'm pleased to see a smattering of younger salesmen and women, and a new generation of buyers as diverse as ever, a glorious gathering of flowers and a brilliant bunch of people.

AUTHOR'S ACKNOWLEDGMENTS

This book has been a gloriously collaborative effort, but the major contributor is the brilliant Michelle Garrett, who slipped into the Flower Market with me each month (for its final twelve months) to record the floral year as it unfolded (the subject of my recent book ***The Flower Market Year***). However, it became clear to us both, but especially to the exquisitely nuanced eye of Michelle, that it is the people who make the Market what it is, and give it its unique and intrinsically British, London-centric characteristics. This book is the sum of Michelle's perfectly captured images – a simple garden-gathered bunch of colourful characters – with the unifying thread of a love of flowers binding them together.

Just as I have had the good fortune to know and work with Michelle for many years, so, too, I have had the benefit of working with my editor, Susan Berry, for all but one of my seven books. Under Susan's direction, ably supported by designer Steven Wooster, a disparate crowd of faces, as varied as the flowers with which they work, have now been assembled into a book. My words, not unlike the foliage supporting a floral decoration, add textural contrast. I am endlessly grateful to them both for always being challenging, creative and caring.

To you all, thank you!

AUTHOR'S BIOGRAPHY

Simon Lycett's company (Simon J Lycett Ltd) enjoys an international reputation as one of Europe's finest floral decorators. Among Simon's notable commissions have been the wedding decorations for TRH the Prince of Wales and the Duchess of Cornwall at Windsor Castle, David and Victoria Beckham, Viscount and Viscountess Weymouth, and Cheryl Cole, and, more recently, for the wedding reception of HRH Princess Eugenie and Jack Brooksbank. For over 20 years, Simon and his team have decorated parties for HM Queen Elizabeth, working at some of London's most exclusive venues, including the Royal Palaces and Windsor Castle.

Simon has appeared many, many times on TV and also at numerous RHS Chelsea Flower Shows. He also presented the BBC2 documentary,' The World's Biggest Flower Market'. He is a frequent guest at the BBC Radio London studio on the Jo Good afternoon show.

Simon spent the early part of 2020 in Los Angeles filming the first series of a flower arranging competition for HBO Max featuring ten of America's budding florists, vying to be voted America's best, with Simon serving as host. He also runs floral master classes and has spent time in Philadelphia, teaching at the world-famous Longwood Gardens.

Passionate about British floristry and seasonal flowers, Simon devotes much of his time to raising their profile. This is his seventh book.

 @simonlycett